SECRET CARLISLE

Andrew Graham Stables

AMBERLEY

First published 2024

Amberley Publishing
The Hill, Stroud
Gloucestershire, GL5 4EP

www.amberley-books.com

Copyright © Andrew Graham Stables, 2024.

The right of Andrew Graham Stables to be identified
as the Authors of this work has been asserted in
accordance with the Copyrights, Designs and Patents
Act 1988.

ISBN 978 1 4456 8273 0 (print)
ISBN 978 1 4456 8274 7 (ebook)

British Library Cataloguing in Publication Data.
A catalogue record for this book is available from the
British Library.

Origination by Amberley Publishing.
Printed in Great Britain.

Contents

Introduction

Carlisle is the largest settlement in Cumbria and serves as the administrative centre of the county. Often described as the 'Great Border City', throughout its early history it has been subject to border movement and overlordship of different nations and people. The earliest known people to have inhabited the area are the Carvetii, an ancient Brittonic Celtic tribe thought to have lived in the Lancashire, Cumbria and Galloway area before the Romans arrived. The name of the settlement was Caer-luel, meaning fortified or stronghold (Caer) of Luel (a name), but this could be 'Liwelydd' in Old Welsh or the Latin 'Luguvalium' as mentioned by Roman historians. The Carvetti are only identified by Roman inscriptions found on a tombstone at Voreda (Old Penrith), as well as milestones at Brougham and Langwathby. They would have lived in roundhouses built within enclosures, surrounded by small cultivated fields and then grazing land beyond. Like many of the tribes of Britain, they are most likely to have lived alongside the Romans in a collaboration and trading capacity, though of course there were various flare ups of rebellion against their rule.

DID YOU KNOW?
The Carvetii were identified on a Roman tombstone found in 1600 at Old Penrith. The stone's inscription was to Flavius Martius, 'a senator on the tribal council of the Carvetii'.

Luguvalium is the name the Romans gave to the settlement and fort, which was established by Quintus Petilius Cerialis circa AD 72 as they pressed their invasion north from Chester and York. The Roman invaders subjugated northern tribes like the Carvetii and the Brigantes, who inhabited the Pennines, Durham and Yorkshire. The fort is now predominantly beneath the medieval castle, and its *vicus* (supporting settlement) grew up to the east of the fort. It was obviously located here to guard the strategic crossing over the River Eden and then it became an important outpost to support Agricola's invasion over the years AD 78–84 into what is now Scotland.

Carlisle's early importance changed when the Antonine Wall was built across the narrow part of Scotland between the Firth and the Clyde from AD 140 to 193. However, by the third century Luguvalium was once again an important military base on the Roman frontier after the withdrawal from the Antonine Wall and became a centre of administration as the principal town of Civitas Carvetiorum – a self-governing territory of the tribal group known as Carvetii. Another fort was built of stone on the same site

around AD 200 by soldiers from the 20th Legion. The Roman troops were withdrawn from Hadrian's Wall around AD 400 and the last Roman soldiers left England within ten years. Gradually, the Roman way of life broke down and many of the Roman towns were abandoned, though this is sometimes questioned.

The Roman period was followed by the kingdom of Rheged, with King Urien and his successor Owain, whose capital was called Caer Ligualid and is thought to have had a population of around 2,000. It is also possible the old Roman fort and surrounding area was completely abandoned, as many of the Anglo-Saxon people had a fear of these ruinous stone buildings. Evidence suggests there was an Anglo-Saxon monastic community here in 685, possibly centred where the cathedral now stands. According to the Life of St Cuthbert, Carlisle and a territory of 15 miles radius was granted to the saint by the king of Northumbria, and when Cuthbert visited Carlisle he is said to have gone to the old city walls where there was a fountain of some sort still functioning. This community is said to have been destroyed by invading Danes c. 875, remaining abandoned until after the Norman Conquest. Despite this, there is some archaeological evidence for occupation through the tenth and eleventh centuries.

By the time of the Norman Conquest in 1066, Carlisle was actually part of Scotland and therefore was not recorded in the 1086 Domesday Book. This changed in 1092, when William the Conqueror's son, William Rufus, invaded the region and incorporated Cumberland and Carlisle into England. The construction of Carlisle Castle began in 1093 on the site of the Roman fort. The castle was rebuilt in stone in 1112, with a keep and the city walls. The walls enclosed the city south of the castle and included three gates to the

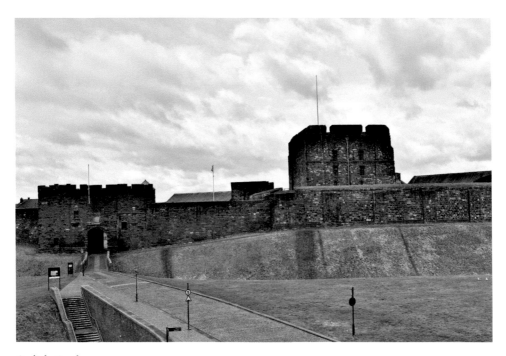

Carlisle Castle.

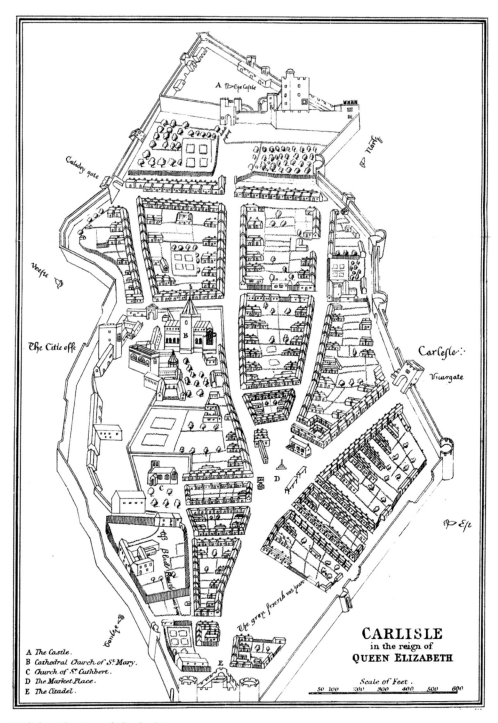

A The Castle.
B Cathedral Church of St. Mary.
C Church of St. Cuthbert.
D The Market-Place.
E The Citadel.

CARLISLE
in the reign of
QUEEN ELIZABETH

Scale of Feet.
50 100 200 300 400 500 600

Carlisle at the time of Elizabeth I.

west, south and east called the Irish or Caldew Gate, the English or Botcher Gate and the Scotch Gate, respectively.

This book will not reveal all the secrets of the city of Carlisle, but I hope to bring you a selection of historical events, people and buildings who have helped to create the character of this fascinating place. It will include stories from the past, chosen because they either piqued my interest or I felt were essential to the story of the city. Some of the history will be well known, and some will be a little less familiar, but all are a crucial part of the story. It is now considered a border town but was once deep inside the Strathclyde and Galloway region and ruled by a powerful king whose kingdom stretched from the River Clyde down to south Cumbria. The history of Carlisle is dominated by the relationship between Scotland and England, and the conflict endured by both sides over the years. Carlisle is on the natural route from west Scotland to the west of England. The city has also endured the ravages of starvation, plague and numerous catastrophic fires but has always responded with courage, ingenuity and stoicism. It is a city built on history and always torn between the crowns of England and Scotland, but willing to modernise and move with the times to continually reinvent itself.

The format and size of this book make it easy to carry around with you while exploring the city and visiting some of the buildings, especially the fantastic Tullie Museum, the castle and the small but beautiful cathedral. On your tours, make sure to partake in the food and drink on offer at one of the many hostelries who ply their trade in the city.

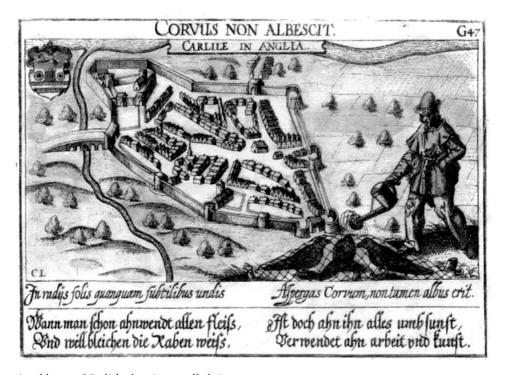

An old map of Carlisle showing a walled city.

When the renowned writer Daniel Defoe visited the city in 1724 he reported that 'the city is strong, but small, the buildings old, but the streets fair ... There is not a great deal of trade here either by land or sea, it being a mere frontier'. Then in 1759 a merchant from Bristol called it 'a small, deserted city, dirty, poorly built and poorly inhabited'. However, the following is from an 1847 gazetteer: 'The approaches to the city on all sides are strikingly picturesque, and its vicinity to a branch of the sea, as well as its due distance from the surrounding mountains, render the air salubrious and temperate.'

In 2012, Carlisle was considered the happiest city in the UK and still ranks consistently high in terms of happiness. It may be the feeling of community as an isolated city, or it may be the sense of a deep and important history. Perhaps it's as simple as the fact that Carlisle is surrounded by beautiful countryside, nature and wildlife.

DID YOU KNOW?
In 2009, during an excavation to the west of the village of Stainton, two very rare wooden 'tridents' were discovered that are thought to be around 6,000 years old.

1. Events and Conflicts

Rose Castle and the Parliament Held in Carlisle

For many years the Bishop of Carlisle's residence was located south of the city at Rose Castle, a bishop's palace. It is now in the ownership of a charity called the Rose Castle Foundation, a charity based on laying the foundations for sustainable peace and reconciliation in the world. Of course, when the palace was built and the bishops were

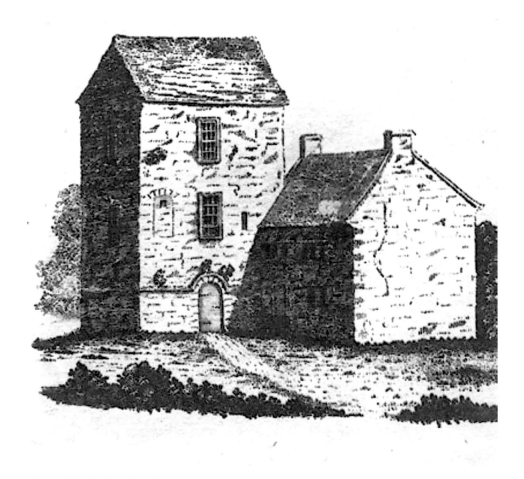

Linstock Castle from Hutchinson.

in power the buildings were defensive structures, built by bishops who may have been warriors as well as religious leaders.

Ironically, Rose Castle was built to the south of the city to afford better protection from the Scots during the Wars of Scottish Independence. Their previous residence had been at Linstock Castle in the parish of Stanwix, north-east of the city and built around the twelfth or early thirteenth century. All that remains is a tower house as part of a farm complex with the remains of an encircling moat. Rose Castle was used as a bishop's palace from around 1219 to the early fourteenth century, when it was used as prison and refuge for villagers during the frequent border raids.

For six days in March 1307, Edward I, his queen and his court were entertained here, while Parliament was held in Carlisle. It does not appear there was ever a palace in Carlisle itself, although it is recorded that when the Parliament was held at Carlisle Bishop Halton (Bishop of Carlisle 1292–1324) petitioned to build a house for himself and his successors on a piece of waste ground outside the precincts of the castle but within the city walls.

A tower is thought to have been built at the west side of the cathedral precincts and named the Bishop's Tower. This may have been used as a bishops' residence and built by Bishop Halton, but the evidence is scant on the subject. The tower was still standing in 1620 but was demolished by 1640, along with other redundant priory buildings. There have been no archaeological investigations in the cathedral precincts to locate the exact position of this long-lost tower.

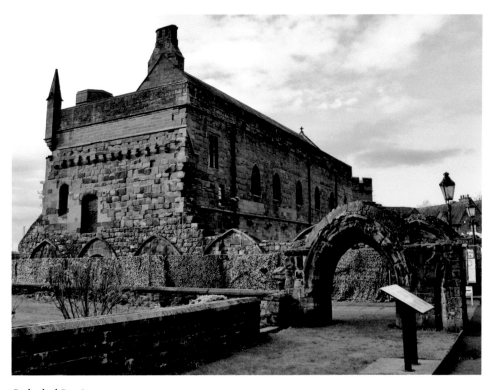

Cathedral Precinct.

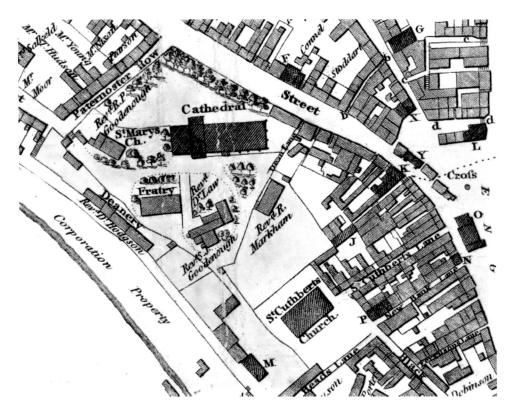

Wood's map of Carlisle centre.

The property where Rose Castle stands was granted in 1230 by the crown to the Bishop of Carlisle, Walter Mauclerk, who also happened to be the Lord Treasurer. It is likely he wanted to move from Linstock Castle due to the proximity to the border and the tumult of the Scottish Wars of Independence. Rose Castle would also become a target for the raids, and its medieval architecture reflects the uncertain nature of border dwelling. Sixty-three bishops of Carlisle have used Rose Castle as their residence. The decision was made to relocate in 2009 to a more humble abode in Keswick.

Pilgrimage of Grace and the Siege of Carlisle

Following Henry VIII and his chief minister Thomas Cromwell's commencement of the Dissolution of the Monasteries in 1536, when royal commissioners throughout England were sent to close down the monasteries, friaries, priories and nunneries, the conservative rural north began to protest. The destruction of religious symbols and the confiscation of the wealth and property of religious houses to bolster the king's exchequer was deeply unpopular. The banning of feast days for Catholic saints and the taxes raised on the peasantry was an even greater reason for dissension.

They demanded that a Parliament be assembled in northern England so these taxes could be abolished, that the attacks on churches and religious houses stop, and that feast day venerations be allowed. The learned lawyer Robert Aske was persuaded to become

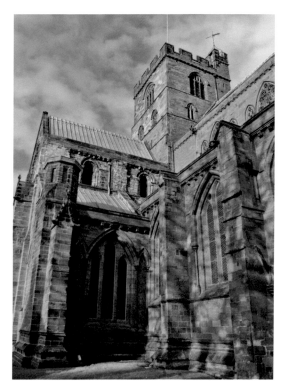

Carlisle Cathedral.

the leader of the uprising and apply pressure by acts of disobedience and resistance to the king's commissioners.

The revolt gained impetus and the peasant army captured Lincoln, with the local gentry unable to quell the vast numbers filled with resolve. Henry VIII sent the Duke of Suffolk, Duke of Norfolk and Earl of Shrewsbury to command a royal army and suppress the uprising and sent a message to the rebels via Cromwell to return home and remember their loyalty to the king. The Lincolnshire rebels dispersed and returned home after being offered a pardon, but in northern England the rebels entered York and celebrated Mass in the cathedral there. Their numbers grew and they proceeded to march on Pontefract Castle, which was held by Lord Darcy. Darcy wrote to the king, beseeching him to negotiate with the rebels as he was unable to hold off the rebel army. He held the castle for the king for two days until 20 October before he surrendered to the rebel leader Robert Aske much sooner than the king felt its strength warranted.

Suffolk advanced north with 5,000 men and set up camp not far from Newark, with Shrewsbury's 7,000 troops being encamped nearby. The royal army was outnumbered with around 12,000 men and lacking in cannon; the rebels, on the other hand, had something like 40,000 pilgrims. Norfolk decided to negotiate with Aske near Doncaster and made promises to avoid a likely defeat. The rebels had control of most of the north and agreed to the proposed truce as their five grievances or articles were agreed to be taken to the king by two of the pilgrim leaders, Ralph Ellerker and Robert Bowes, accompanied by the Duke of Norfolk.

The truce held throughout the month of November, until the pilgrims' council met at York, where Robert Bowes gave an account of his visit to the king at Windsor and reassured them as to the king's mercy. Henry was willing to pardon all but the ten ringleaders. The pilgrims' representatives were summoned to a second appointment to discuss the situation with the Duke of Norfolk, but the issue of a free and general pardon for all rebels was a major part of the debate. Meeting at Pontefract in early December, Norfolk advised that it would not be honourable for Henry to grant a free pardon as the king's honour would be gravely diminished. However, Norfolk was forced to grant a free and general pardon due to the rebels' ongoing military strength.

The pilgrims drew up twenty-four articles (known as the Pontefract Articles) on 4 December, which included religious grievances and criticisms of the Dissolution of the Monasteries and royal supremacy. They petitioned that the king's daughter by Katherine of Aragon be declared legitimate and also asked for a Parliament to be convened in either Nottingham or York. These twenty-four articles were to be taken to the king and a general pardon be granted. In addition, the restored abbeys were allowed to remain. Two days later, a herald brought the general pardon and confirmation that a Parliament would convene at York (no date was given). They met with Norfolk at Doncaster and, feeling the mission was accomplished, tore off their pilgrim badges (of the Five Wounds of Christ) and dispersed.

John Constable and Ralph Ellerker went to London, where the king decided to offer a general pardon to the rebels while further negotiations were carried out with the rebels in the north. Constable was not happy with the negotiations, and a copy of a letter from Cromwell threatened to violently crush the rebellion as a reminder to fear the monarchy. However, Aske agreed to negotiations in York with the Duke of Suffolk and confirmed that King Henry would hold a special Parliament at York. Negotiations continued on the other articles, but the duke was clearly playing for time and, with Christmas fast approaching, the rebels were persuaded to go home. Aske was convinced that the rebellion had succeeded in ensuring that their faith had been maintained and without bloodshed. Aske was granted an audience with King Henry on the condition of safe passage to and from the court. He was treated well and the king even gave him a coat as a gift. He promised to travel to York for his wife Jane Seymour's coronation and allowed for his daughter, Princess Mary of England, to visit Aske, whom she praised (he then said that he wanted for her to become the next ruler of England).

Aske returned to Pontefract Castle and repeated the king's good intentions, but the men distrusted the king and his representatives, and had already made up their minds to continue the rebellion. John Constable declared his intention to march on to Carlisle. Aske was angry and said they were putting the hard-won agreement in jeopardy with this continued action. The king sent Suffolk to northern England to force the pilgrims to accept an oath in which they would swear their allegiance to the king and acknowledge their past sins. The king's delays and promises were seen to have been successful in dividing the rebel leaders and effectively breaking up many of the dissenters.

The pilgrimage found many sympathisers in Cumberland and Westmorland, including among the clergy of Carlisle, Lanercost and Penrith, who were considered especially obnoxious to the king by their activity. Penrith appears to have been the local focus of insurrection and

was complicit in the sending of men to the throng of rebels. Men from Kendal, Richmond, Kirkby Stephen, Appleby and Hexham were involved in the siege of Carlisle.

As these rebels gathered near Carlisle, preparing to besiege the castle, the Duke of Suffolk led his men in an attack on the rebels. Caught between the city walls and the royal

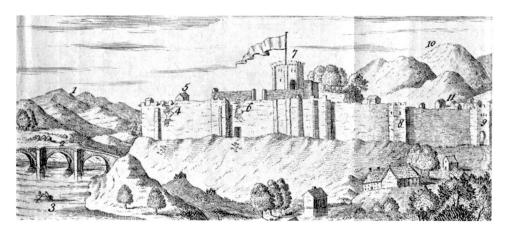

Perspective of west Carlisle.

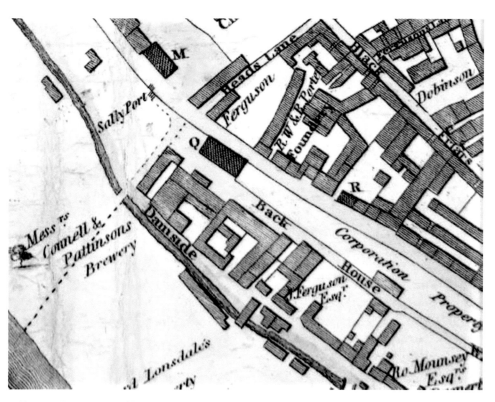

Sally port shown on an old map.

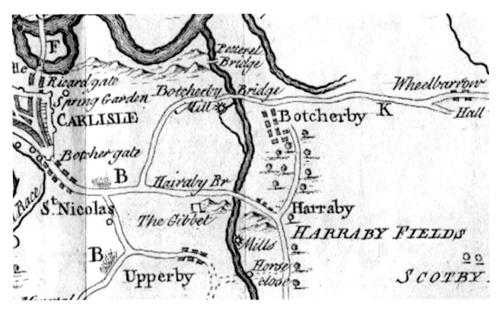

Map of Harraby showing the location of the gibbet.

army, the rebels were driven from the field or captured to await their fate. Constable was captured and told he would be taken to London to be tortured while many more were hung from trees to demonstrate the brutal power of the throne.

The Duke of Suffolk moved on to Pontefract, where he challenged Lord Darcy, Ellerker and Aske, who all informed Suffolk that they were against the continued rising and that they had not betrayed the king. Suffolk said he was sure of their loyalty, but they must come with him to give their explanation for recent events. He assured them that he would write to the king in their favour and they were persuaded to go with Suffolk. Darcy, Ellerker and Aske were imprisoned in the Tower of London, where Darcy and Constable were beheaded for treason. Aske was sentenced to death and sent to York, where he was hanged in chains. Ellerker was pardoned, but only after he confessed his sins, and he was wracked by guilt after his friends were killed.

Gallows, Gaols and Gibbets

There seems to have been a few places of execution in and around Carlisle over the years. Harraby Hill, around a mile and a half south-east of Carlisle, was the site of the gallows where many were executed, including several Jacobite prisoners in October and November 1746. Sir Archibald Primrose of Dunipace had been imprisoned in Aberdeen for his part in the uprising and was moved to Carlisle for trial. He met his end at Harraby Hill after handing over a letter for his sister to a friend at the foot of the scaffold. He had hoped for a pardon having pleaded guilty and thrown himself on the mercy of the court, believing this would allow him to avoid the noose. No pardon arrived in time to save him, though there is a rumour that a reprieve arrived half an hour after his execution. He and many of the other executed Jacobites are buried in an unmarked grave in St Cuthbert's Churchyard.

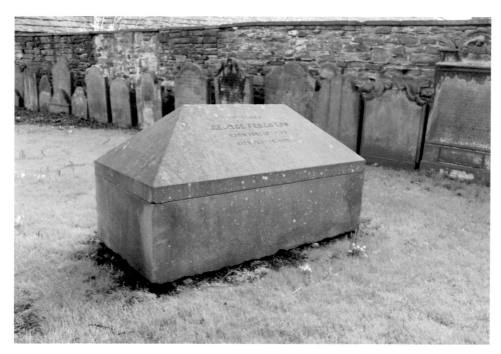

Grave markers at St Cuthbert's.

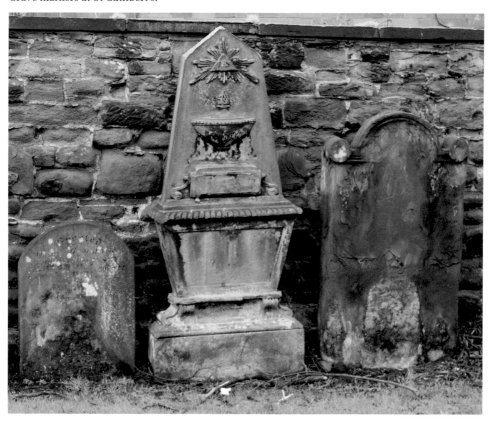

Another grave marker at St Cuthbert's.

Although many were executed for murder or theft, Anthony Mason was hung on 15 September 1753 for 'sending a threatening letter'. He was guilty of sending Peter Howe an undated and unsigned letter demanding money.

Reference is made to 'hundreds of lewed, disorderlie, and lawlesse persons, commonlye called moss-troopers, had the ill-luck to be justified, after reciting their neck-verse, with the assistance of a priest'. The first verse of Psalm 51 had come to be known as the 'neck verse' because, historically speaking, the ability to read it aloud was a way to escape the gallows in England. To ensure that an offender could escape death only once through the benefit of clergy, he was branded on the thumb with an M for murder or a T for theft. Branding was abolished in 1779.

Adam Graham was hung in chains at Kingmoor for murder in September 1748. Hung in chains usually meant in a gibbet, and Adam Graham's gibbet was apparently 12 yards high and had 12,000 nails in it to prevent it from being scaled or cut down to remove the body.

Another reference is from a 1791 map. A Hangman's Close is shown to the east of the castle, where Corporation Road is now. This could be a reference to Low Sands where other hangings were carried out for a time.

Carlisle Gaol also took over the hangings for a period of time. The last public hanging was carried out in March 1862 when a thirty-two-year-old engine driver called William Charlton was hanged for the murder of seventy-two-year-old Jane Emerson, the gatekeeper at the Durran Hill crossing on the Carlisle to Newcastle railway line. There were still a number of private hangings held at the Carlisle Gaol after this, however.

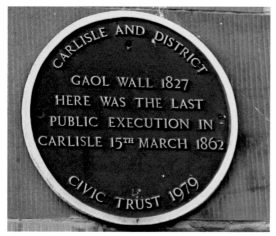

Plaque on the old gaol wall.

Old gaol.

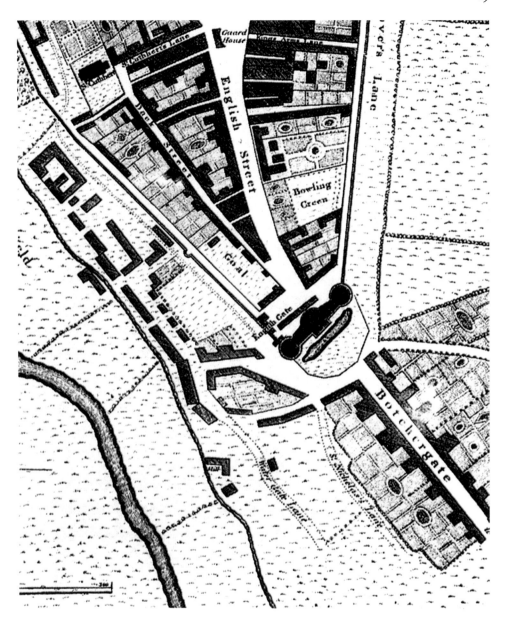

An old map showing the gaol.

Sieges

There have been many sieges at Carlisle, especially during the Scottish wars, with significant events in 1135, 1173, 1216, 1217, 1296 and by Robert de Brus (the Bruce) in 1315. The latter siege was particularly well documented in the Chronicle of Lanercost:

> The Scots applied many long ladders, which they had brought with them, for the purpose of ascending the wall, and a sow for undermining the wall of the city, but neither the sow

nor the ladders availed them of anything. They also made bundles of straw and grass in great abundance, these to fill up the moat, without the wall, on the east side in order to pass over it dry. They also made wooden bridges, running on wheels, that may be drawn forcibly and rapidly with cords, but the bundles could not fill up the ditch even during all their stay, nor bridges pass the ditch, but fell by their weight to the bottom. The Scots were reduced to attacking the gates, all of which were bravely defended by the citizens within the city.

Further sieges of Carlisle occurred during the English Civil War when the town was held by the Royalists against the Covenanters in 1644 and 1645. Later, during the Jacobite rising in 1745, the city was besieged and taken by the Scots in November, only to be retaken by the forces under the Duke of Cumberland.

Sometimes the city was captured and sometimes the sieges failed. This may have been by certain strategies or a *coup de main* or, indeed, betrayal, all of which were employed at different times in the history of the walled city of Carlisle.

Chronicle of Lanercost (1272–1346)

Often used as a source of information from the period of the reigns of Edward I and II and part of Edward III's reign, the chronicle is not without its controversy. Firstly, it is a very partisan view of the Wars of Scottish Independence, but this may be expected from a writer living just across the border, but there is also a question over who it was written by and where.

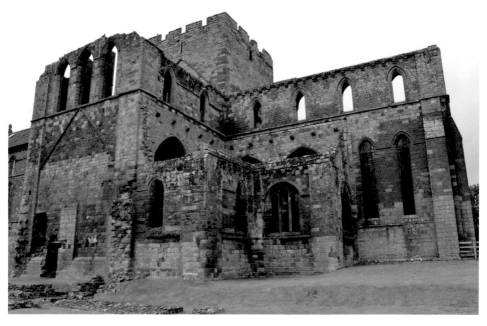

Lanercost Priory.

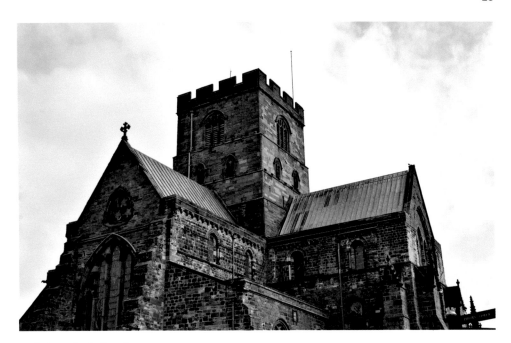

Carlisle Cathedral roof.

Translated from Latin by Joseph Stevenson around 1839, in his opinion there is no merit for attributing the origin of this chronicle to the Priory of Lanercost. He judged from the evidence he found that it was written by a Minorite friar of Carlisle. This was judged once more by Dr James Wilson, who believed the Augustinian Priory of Lanercost was the source of the chronicle. Others still debate the origin of this important historical source, but the fact remains that the chronicle is a useful insight into a way of life at this time in our history.

DID YOU KNOW?
Carlisle does not feature in the Domesday Book (1086) as at the time it was in the possession of the Scots.

Fire

In May 1292, Carlisle was devastated by a fire. A sensationalist account of the event appears in the Chronicle of Lanercost:

Satan even caused the son of a certain man to set fire to his father's house outside the town at the west end of the cathedral church, and this, escaping notice at first, soon spread over the whole town, and, what is more, it speedily consumed the neighbouring

hamlets to a distance of two miles beyond the walls, and afterwards the streets of the city, with the churches and collegiate buildings, none being able to save any but very few houses. The fire, indeed, was so intense and devouring that it consumed the very stones and burnt flourishing orchards to the ground, destroyed animals of all kinds; and, which was even more deplorable, it burnt very many human beings of different ages and both sexes. I myself saw birds flying about half burnt in their attempt to escape.

Records tell us that almost the whole city was consumed. This frightful conflagration is said to have been caused by somebody who, motivated by resentment, set fire to his father's house. He was executed for the crime. The king, in his good grace and due to this calamity, reduced the taxes due to him to give time for the people to recover from all that was consumed by the flames.

Within a few years, and in all likelihood, with some repairs to the city still unfinished, tragedy would strike again. In March 1296, following Edward I's involvement in the Scottish succession, the Earl of Buchan attacked Carlisle. Though he was successfully opposed by the inhabitants, fire once again struck the city. Half of the city was lost once more when a Scottish prisoner managed to start a fire in the prison. The medieval city would have been mainly timber-framed buildings with thatched roofs, with the city walls, churches and fortifications being the obvious exceptions. The fire even destroyed parts of the cathedral, including a wooden ceiling, but very soon after this disaster they began rebuilding the choir, piers and east bay. They also took the opportunity to change the street pattern after the fire, with several diverted streets and changes to the main castle entrance.

William Hutchinson also refers to an earlier fire in his histories, and it appears a great deal of the town records went up in smoke at the time:

King Henry Fitz Empress [Henry II] took Carlisle and the county from the Scots and granted to the city the first liberties I hear of, that they enjoyed after the Conquest. But his charter was burned by a casual fire that happened in the town, which defaced a great part of the same, and all the records of antiquity of that place.

In 1251, Henry III granted another charter to replace the one that had been lost by fire.

Another fire broke out in 1391 when a reported 1,500 tightly packed timber-framed houses were lost. Though Towill believes this figure may have been exaggerated to gain more support in the rebuild; indeed, the king granted 500 oaks from the Forest of Inglewood to assist the inhabitants.

Further destruction occurred in 1644 when General Lesley and a Scottish army on the side of the Parliamentarians laid siege to the city. Although the city held out for around eight months, it suffered fire and cannon as well as starvation before they surrendered.

Battle of Solway Moss, 24 November 1542

The Battle of Solway Moss was the last of a series of battles that arose from a disagreement between Henry VIII of England and his nephew, James V of Scotland. Following Henry's break from the Roman Catholic Church, he asked James to do the

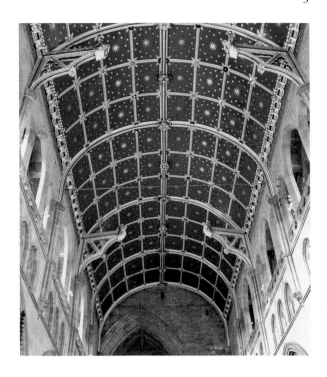

Cathedral ceiling.

same, but he refused. Henry set up a meeting between the two monarchs at York in 1541 to discuss the issue and no doubt to bully James to acquiescence, but he refused to attend. Henry felt insulted by this rejection and sent his army to raid and harry various Scottish border towns. Infuriated by his uncle's behaviour, James decided to strike back and gathered an impressive force of around 18,000 men to attack the English border towns. James V sent Robert, Lord Maxwell to carry out this mission and cross the border into England.

A much smaller force of 3,000 Englishmen gathered at Carlisle to fight off the Scottish, led by Sir Thomas Wharton and Sir William Musgrave. With overwhelming odds against them, the sensible ploy would have been to bring his army behind the defences of Carlisle and prepare for a siege. But Wharton was an experienced, skilled and confident leader, and he preferred to engage in open battle. He must have also felt the sooner they engaged the Scots, the sooner he could end the destruction to the border villages and towns. Wharton led his troops out from Carlisle to confront the Scots, who were pillaging and burning through lands along the border immediately beyond the River Esk.

The vastly superior numbers of the Scottish forces should have made short work of the English army. But lack of cohesion among the Scottish leaders, combined with skilful use of troops and topography on the part of the English, led to a humiliating Scottish defeat. The battle took place around the River Esk and the River Lyne, on the English side of the border in Solway Moss. When the English force crested a hill, now known as Oakshawhill, the Scots saw them and feared the English were backed by a much larger force. The Scottish hesitated and infighting between Lord Maxwell and James V's favourite, Oliver Sinclair, stoked dissension amongst the Scottish troops and caused the army's structure

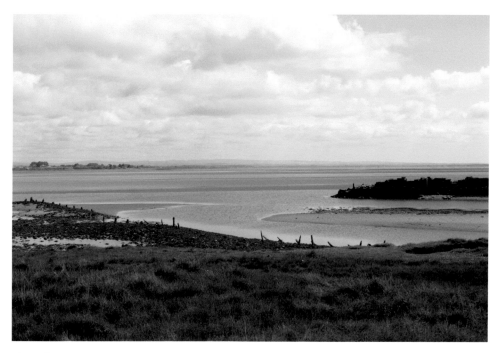

The Solway.

to come undone. The cavalry of the English army swiftly descended on the Scots, causing most of the Scottish troops to flee or otherwise surrender. The Scots were caught between the River Esk and the Solway Moss and had nowhere to flee. As the fighting began, many of the Scots drowned in the River Esk and many surrendered, handing over their ten or so field guns to the English.

It is estimated that the Scots lost approximately 1,200 men, with the English only losing less than ten. The defeat at Solway Moss was devastating to James V, who died only a couple of weeks later on 14 December 1542. James had been staying in the safety of Lochmaben, but after the defeat he retired to Falkland Palace. He was delirious with fever and is said to have lamented the death of his favourite, Sinclair, and the defeat at Solway Moss more than anything. His death left his six-day-old daughter, Mary, as Queen of Scots.

Famine

In 1623, parts of England were struck by a major famine which would bring further misery to a beleaguered people. Following a record poor harvest in 1622, the following year resulted in high wheat prices and low sheep prices, which led to famine in the area. Though mainly contained to the north-west of the country, Cumberland, Westmorland and Dumfriesshire suffered particularly badly. There was a significant rise in burials at this time, estimated to be around 20 per cent of the population. In previous years the plague had taken an estimated 40 per cent, and followed by this latest tragedy, the population was severely depleted.

Most of the country appears to have been stricken by the famine, but extensive starvation was generally confined to the upland north and west. Even in parts of the lowland east of England the situation could be desperate. One Lincolnshire landlord reported how one of his neighbours had been so hungry he stole a sheep, 'tore a leg out, and did eat it raw'. 'Dog's flesh', he wrote, was 'a dainty dish and found upon search in many houses'. With the famine noticeably worse in the highlands of the north-west, even in Lancashire it has been calculated that famine killed about 5 per cent of the population. In parts of Cumberland and Westmorland there were reports of the poor men, women and children starving to death in the streets.

The famine of 1623 is recorded as the most significant in English history and though it returned every decade or so, it never again resulted in such widespread mortality. There were reports of famine in Cumberland and Westmorland in the late 1640s, possibly during and because of the Civil War. There were further spikes in the death rate around 1727–30 when repeated outbreaks of disease coincided with two bad harvests. But 1623 was the real defining moment and can be classed as England's last real famine.

DID YOU KNOW?
In 1600 the population of Carlisle is estimated to have been 2,500 souls.

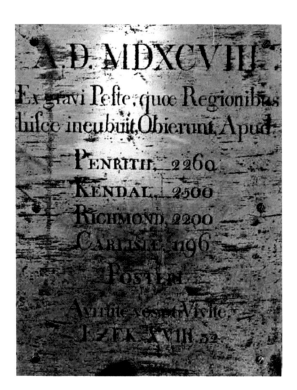

Brass inscription about the plague outbreak in St Andrew's Church.

Coach Road Accident

On 2 November 1835, as the mail coach was returning from Carlisle to Newcastle, it was upset about 2 miles west of Hexham when one of the wheel horses (one of the horses harnessed behind the others and nearest the front wheels of the coach) fell. The remaining horses, along with the coach, were caused to collapse into a ravine. The coach rolled over two or three times, until it was stopped by a tree. The coachman, John Atkin, was thrown from his seat and was so terribly injured that he died almost immediately. Two outside passengers escaped by leaping off the coach as it began to tumble. Two ladies and three children who were inside also escaped uninjured, although they rolled down the bank. The passengers and mailbags were recovered and transported to Newcastle.

Garrotters Captured in Carlisle

In the mid-1800s there seems to have been a large number of attacks by gangs of garrotters in the country, and in July 1857 there was a breakout from Newcastle Gaol of four such men. Two of the men, Blakeston Hind and George Bell Winship, were well-known lawless characters. They had been charged with garrotting William Oley and robbing him of a large sum of money. Another man, William Hayes Beaumont, had been accused of a garotte robbery at Arthur's Hill in Newcastle. The fourth man, John Harris, who was a tailor, had committed a murderous assault upon his paramour.

Apparently, due to the incompetence of the turnkeys (jailers) who left several cells unlocked at night, several prisoners were able to leave their cell, but only the four characters above were desperate enough to scale the walls. They placed a long plank against the inner wall near the work yard, which adjoins the outer wall. Then, using a rope made by tying their bed rugs together, managed to lower themselves down to the street – a height of upwards of 20 feet. One of the men dislocated his ankle on landing and, as he could not walk, the others dragged him to an arch close by and 'pulled the ankle right again'. They were then free, moving in the direction of Arthur's Hill, and within a few days they made their way to Carlisle where they were arrested after suspicions were raised when they were spotted looking miserable and barefoot. They were sentenced to death, a sentence that was commuted to transportation for life.

Carlisle Historical Pageant

In 1928, Carlisle held its first historical pageant featuring well-known characters from history associated with Carlisle such as Hadrian, St Cuthbert and Mary, Queen of Scots. The event was a grand affair with around 4,000 people taking part in the activities, all dressed in costumes to reflect the portrayals. The event was held in Bitt's Park to ensure it was as close to the city centre as possible.

The 1920s were a difficult time for many people and not everyone could afford a ticket to the pageant. Cheap seats were made available for the six dress rehearsals, with most seats costing only 1s. Another way to see the event was to volunteer to be a steward and watch for free, but it required stamina as the performance lasted over three hours. For most people the only option was a place in the standing enclosure, which cost a halfpenny.

The 1928 pageant was considered a success and the Silver Grill Bakery and Restaurant in English Street commissioned paintings of some of the most memorable scenes from

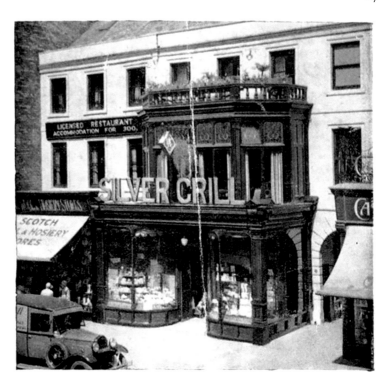

THE CARLISLE HISTORICAL PAGEANT
August 6th to 11th, 1928

A description of the Pageant as illustrated by the series of
Paintings upon the walls of the Pageant Hall, Silver Grill, Carlisle,
by
W. T. Mc.INTIRE, B.A., F.S.A., Scot.

Pageant
programme.

PRICE 3d.

the show. These were exhibited on the walls of one of the restaurant's function rooms, renamed Pageant Hall in honour of the images. But when the Silver Grill closed in 1964 the paintings went missing. No prints of the originals have ever been discovered, but from a pamphlet printed at the time it is known that there were at least eleven paintings. One showed Princess Mary, who attended the pageant, and others depicted the arrival of Hadrian, Edward I handing out justice to the Scots, and the audacious escape of Kinmont Willie (the famous reiver) from Carlisle Castle.

DID YOU KNOW?
During one of the dress rehearsals for the 1928 pageant an understudy called Miss Stuart, the daughter of the dean of Carlisle Cathedral, fell off her horse when it was entering the arena. Despite being injured, she carried on to the end of the performance.

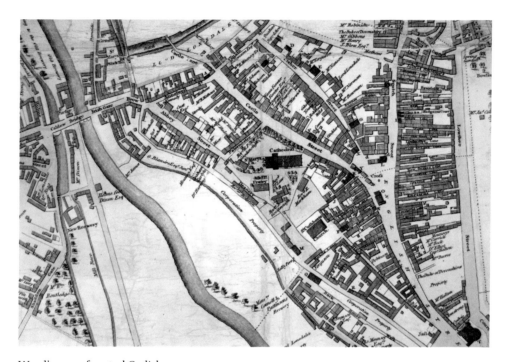

Wood's map of central Carlisle.

2. People

Gnaeus Julius Agricola

It is possible Carlisle began with this Roman career soldier, but if not, he certainly had a significant influence, and in all likelihood he was responsible for a major part of the works at the fort. The fort was one of the bases used as part of his mission to establish a powerful base in the northern extent of the empire. Some recovered timbers date the fort to AD 72–73, though Agricola was not made governor of Britain until AD 78, which suggests the first timber fort may have been started as part of Quintus Petilius Cerialis' campaign against the Brigantes tribe, who rebelled under their leader, Venutius. The Romans moved out from York to take on the Brigantes and crossed the Pennines from Catterick following the route of the modern A66 road. The temporary marching camps at Rey Cross, Crackenthorpe and Plumpton Head (known as Old Penrith) near Penrith have all been attributed to the campaigns of this governor.

Agricola began his career as a military tribune in Britain and may have been involved in the defeat of Boudicca in AD 61. It was during Agricola's support of Vespasian to

Old Penrith (Voreda) on the A6 road.

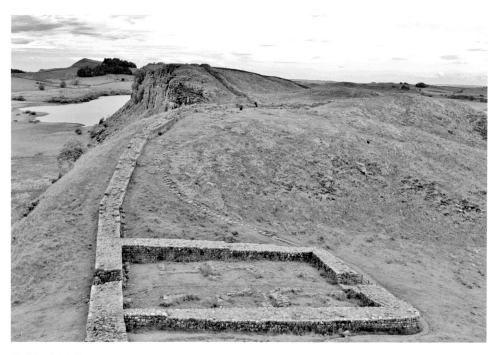

Hadrian's Wall.

become emperor in the Roman civil war of AD 69 that Venutius took advantage of the disruption to rebel against the Roman rule. His reward for his support of Vespasian ensured his rise to command of a legion in Britain under Quintus Petillius Cerialis, who was the governor between AD 71 and 74, and Agricola was later appointed as governor of Aquitania (south-east France). Continued resistance in Britain led to his appointment as governor of Britain and an immediate campaign in North Wales, including the clearing of the druids in Anglesey.

Using Chester and York as strong points and establishing forward bases at Carlisle and Corbridge, over the next few years he moved north into Scotland. He even ventured beyond the line of the rivers Forth and Clyde and confronted tribes beyond the Tay. Renowned for his fort building and ensuring the security of his supply line north, it is inconceivable that he did not improve the fort at Carlisle in his pursuit of his advance. By AD 84 he was successful in crushing the Caledonians in a battle at Mons Graupius, but at the end of the year his feats warranted the attention of Emperor Domitian, who ordered him back to Rome. Once in Rome he was 'granted triumphal insignia, though not actually afforded a triumph' – honours reserved for members of the imperial family.

Gnaeus Julius Agricola died on his family estates on the Mediterranean coast at Provence in southern France on 23 August AD 93 at the age of fifty-three. He was forced to spend his last eight years in a form of imposed retirement, which seems scant reward for such a successful military career.

Andrew Harclay, Earl of Carlisle

Andrew Harclay or Andreu de Harcla, as he was more usually known when he was alive, is a fascinating character linked to the story of Carlisle. Born *c.* 1270 into a low-ranking Westmorland knightly family, he rose to be the sheriff of Cumberland and eventually the Earl of Carlisle, only to have his life snuffed out as a traitor to the crown. His father was in the service of the Clifford family, and it is known Andrew distinguished himself as a soldier in the Anglo-Scottish Wars, which broke out in 1296. He assisted Robert de Clifford, Lord of the Marches in the defence of further Scottish incursions, and in 1311 was appointed sheriff of Cumberland. This was followed by becoming a Knight of the Shire in 1312 and warden of Carlisle Castle in 1313.

In 1315, Robert Bruce led his army into the north of England. From 22 July, he laid siege to Carlisle for ten days. Systematically and relentlessly, they attacked one of the city gates for every day of the siege, and on occasion multiple gates at once, but the defenders fended them off by arrows, darts and spears. The besiegers were so beaten back by the number of objects being hurled at them they 'wondered whether stones were breeding inside the walls'. Midway through the siege, the Scots set up a machine to fire stones at the wall and a gate and proceeded to rain down stones in a constant barrage, but this did little damage to the wall and killed only one man. Inside the city were at least seven similar machines throwing darts and stones, all of which harried and injured the besiegers. Other Scottish siege towers built to attack the walls sank and stalled in the boggy ground outside the walls, becoming completely ineffective. At the end of ten days the Scots abandoned the siege and even left their siege engines behind. Edward II was so pleased with Andrew's efforts he was rewarded with 1,000 marks, and when Edward granted Carlisle a royal charter in 1316 it had an illuminated letter depicting Andrew throwing a spear at a Scottish soldier.

Illustration of the Harclay coat of arms.

In late 1315 or early 1316, Andrew was captured by the Scottish – perhaps in a raid over the border – and held for ransom. Some records state he asked Edward II for help with the ransom as he could not raise the amount himself and was released once the king had paid 2,000 marks. Whatever the truth, he was soon back defending the north-west of England against further attacks, forays and skirmishes.

In March 1322, Andrew Harclay was made Earl of Carlisle after his successful command during the Battle of Boroughbridge, which was the final action of a lengthy dispute between Edward II and his cousin Thomas, Earl of Lancaster.

Andrew took part in Edward's unsuccessful campaign into Scotland in 1322 but was unable to come to his aid at the Battle of Byland, when the king was almost captured near Rievaulx Abbey on 14 October. Edward II was a poor leader who was prone to the promotion of favourites and continually failed to protect the north of England against the Scottish invaders. As a result, Andrew Harclay, emboldened by his elevation to earl and the lack of confidence in the king, decided to try and end the war through a treaty with Robert Bruce. It was late 1322 and the Scots invaded via the Solway and stopped at Beaumont, 3 miles outside Carlisle, taking livestock and destroying crops. Without royal approval, Harclay made a peace treaty in which he and the Scottish king would be arbiters, the treaty being concluded in early January 1323. As soon as Edward learnt of this breach of protocol, Harclay was summoned to report to him, but he declined. The king then sent some local lords to arrest him, who were only too happy to rid themselves of this upstart. They took the earl by surprise, arresting him in the great hall of Carlisle Castle. After a show trial he was condemned to a traitor's death by hanging, drawing and quartering, with his head to be displayed on London Bridge and the four quarters of his body to adorn prominent positions in Carlisle, Newcastle, Shrewsbury and York. He is said to have uttered, 'You have divided my carcass according to your pleasure, and I commend myself to God,' as he was dragged through the streets with his hands held aloft in prayer. His punishment was carried out on Harraby Hill, just south of the city, also known as Gallows Hill. There is an account of his head being sent to Knaresborough, where Edward was in residence, to enable him to examine his once loyal subject.

However you look at this story and the rise of Harclay to his great position, he seems to have been a capable military thinker and devoted protector of the north. His main problem seems to be that he was around at the same time as a fickle and self-obsessed king, whose skill in the field did not match his ambition.

The earldom of Carlisle remained dormant for almost exactly 300 years afterwards, when James I awarded it to James Hay in 1622, who served in various positions at court. His son, another James, inherited the title but remained childless, so it became extinct. The third creation of the title was in 1661 when it was awarded to Sir Charles Howard, of the prominent Howard family. Their principal family seat today is Naworth Castle in Cumbria, while Castle Howard in Yorkshire is held by another branch of the family.

William Strickland, Bishop of Carlisle
William Strickland was born into the Strickland family of Sizergh (near Kendal) in 1336 and became the Bishop of Carlisle. It is believed he served as the rector of Ousby and parson of Rothbury before becoming the chaplain to Thomas Appleby, Bishop of Carlisle.

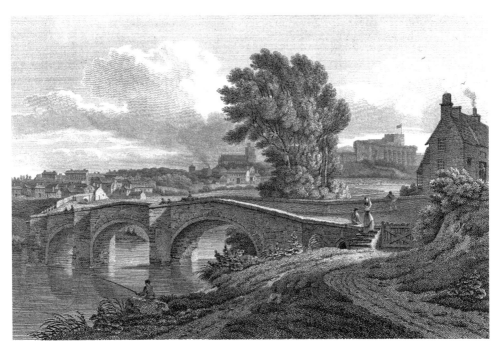

View of Carlisle.

He was appointed bishop in 1396 by Pope Boniface IX, but at first was not accepted by the king. He was not recognised until 1400, after he had been elected by the chapter and an agreement reached with the king. Strickland was then consecrated by the Archbishop of York at Cawood, in Yorkshire, on 24 August.

Strickland was one of the commissioners sent to negotiate peace with Scotland in 1401, and in 1402 was engaged to arrest any persons suspected of claiming that Richard II was still alive (he had been deposed and it is believed he starved to death at Pontefract Castle). In 1404 he was granted the office of constable of Rose Castle, and Strickland was one of the witnesses of the act declaring the succession to the crown in 1406, which entailed the crowns of England and France upon the king's four sons.

Strickland held lands around Cumbria. During the reign of Richard II he was given licence to crenellate, but it is uncertain if this was part of Hutton Hall or Rose Castle. He added a tower and belfry to his cathedral in Carlisle and built the tower at Rose Castle. One of his main achievements was the cutting of a watercourse, known as Thacka Beck, from the River Petteril, through the town of Penrith and on to the River Eamont. This provided a waterway through the town and helped supply fresh water and sanitation.

Strickland died in 1419 at Rose Castle and was buried in the north aisle of Carlisle Cathedral, as he requested in his will.

Mary, Queen of Scots
Mary Stuart was sent to France in 1548 to be the bride of the dauphin (the young French prince) and thus secure a Catholic alliance against Protestant England. In 1561, after the

dauphin, who was still very young, died, Mary reluctantly returned to Scotland, a young and beautiful widow. But after a short and tumultuous reign as the Queen of Scotland and following a loss at the Battle of Langside on 13 May 1568, Mary escaped across the Solway Firth to Workington. The following morning Richard Lowther, the deputy governor of Cumberland, escorted Mary to Carlisle Castle. As Mary's intentions were uncertain at this point, she was placed under armed guard and housed in what was then known as the Warden's Tower. The Warden's Tower, in the south-east corner of the inner ward, would later become known as Queen Mary's Tower. Being the original Norman entrance, records show that it was one of the oldest parts of the castle.

Queen Elizabeth was anxious to ensure this Catholic queen in her kingdom was kept under control so sent Sir Francis Knollys, one of her trusted courtiers, to Carlisle Castle to keep a wary eye on Mary. Sir Francis found his prisoner a charming person and indeed came to like and respect this Scottish queen. Sir Francis lived with the fear that Mary would escape, though he granted her certain privileges such as letting her walk on the grass in front of the castle (known later as 'the Lady's Walk'). His fears were raised on one occasion while out on horseback to hunt hare, 'she galloping so fast upon every occasion'; he said that this could not happen again.

She would constantly implore Elizabeth for help, having arrived with only a handful of attendants. Mary was allowed to send for many of her old staff, as well as her own clothing. Fairly quickly, cartloads of her clothes and personal effects soon arrived from Loch Leven. The queen had cut off much of her hair after the Battle of Langside in an attempt to escape being recognised, and one of her ladies-in-waiting called Mary Seton styled it so skilfully that 'every other day-lighte ... she hath a new devyce of head dressing'. She borrowed money from some of the Carlisle merchants to help her keep up her royal appearance, though much of the cost of maintaining her little court fell mainly on Elizabeth I.

The tower where she was held was demolished in 1835 as it was on the verge of collapse; all that now survives is an octagonal turret housing a staircase that once gave access to the tower.

DID YOU KNOW?
During Mary, Queen of Scots' incarceration at Carlisle Castle, Elizabeth paid around £56 a week for her food, clothing and heating, as well as paying for her gaolers and guards.

In July, Mary was moved from Carlisle to Bolton Castle in Yorkshire due to the threat of influencing Catholic families in the north to release her and use her person to rally support in a return to the old religion. The journey is supposed to have taken two days. She stayed overnight at Lowther Castle near Penrith and Wharton, though it is amazing the amount of places that claim to have housed her on her journey south. In early 1569

she was moved to Tutbury Castle in Staffordshire, but it seems she foolishly continued to involve herself in intrigue and plots. She was later taken to Fotheringhay Castle, and on 13 October 1586 she was tried for treason. Though she protested her innocence, after nineteen years in captivity and much soul searching by Elizabeth I, Mary, Queen of Scots was executed by beheading on 8 February 1587.

Prince William Augustus, Duke of Cumberland and Bonnie Prince Charlie

Forever linked together in history, Charles Stewart (Bonnie Prince Charlie) and William, Duke of Cumberland were the leaders on opposite sides of the Jacobite rising of 1745. On his way south with a Scottish army, Charles captured Carlisle Castle on 14–15 November 1745 and installed a new garrison. Charles apparently slept at Highmoor House, on the site of Marks & Spencer now, before continuing south in his attempt to secure the British crown. The advance stalled near Derby and the Scottish retreated back the way they came, pursued by the Duke of Cumberland with his forces. The duke took back the castle on 30 December after another siege, sleeping at the same place as Charles had done over a month before. As a one-off this may seem perfectly normal, except this also occurred in Kendal when they slept at Thomas Shepherd's house on the way south and on his return north in 1745. Ultimately, the Scottish army was defeated at the Battle of Culloden in April 1746 and Charles fled into European exile, his cause forever lost.

Plaque commemorating Bonnie Prince Charlie.

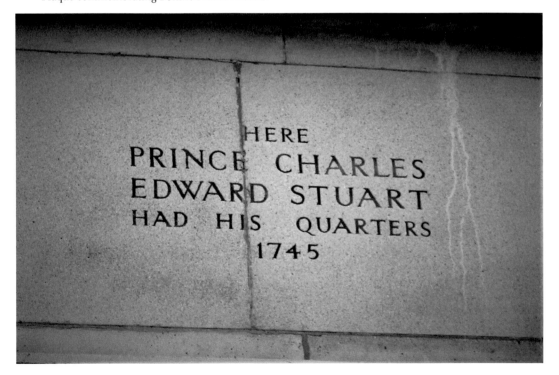

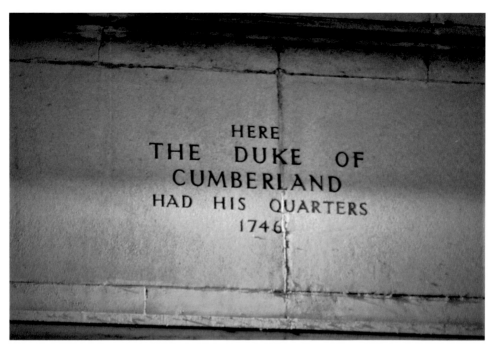

Plaque commemorating the Duke of Cumberland.

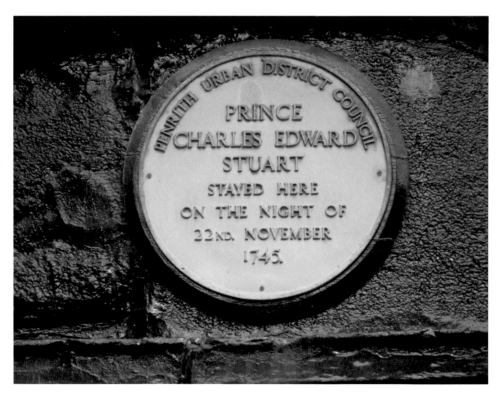

Plaque in Penrith recording Bonnie Prince Charlie's journey south.

John Hatfield, Imposter and Forger

Though born in Cheshire in 1759, John Hatfield's fate is forever linked with Carlisle. He was visited here by Coleridge and the Wordsworths while a condemned man, and it was also the scene of his trial and execution.

John was a lowborn fellow who began as an agent to a linen draper in the north of England. During this time, he discovered that a young woman under the guardianship of a local farmer was in fact the daughter of Lord Robert Manners, and her husband was to receive a dowry if she married with her father's approval. He pressed his interest in the young woman, who was taken in by his charm and 'good complexion'. Upon their marriage, sometime around 1771/72, the lord presented the bridegroom with a draft from his banker for £1,500. Hatfield soon set off to London where he was a regular visitor to the coffee houses in Covent Garden, describing himself as a near relation of the Rutland family and boasting of his parks and hounds. When the money was spent, he was scarcely heard of until around 1782, when he was again in London after having abandoned his wife and three daughters and had been committed to King's Bench Prison for a debt of £160. Here he persuaded a clergyman to lay his case before the Duke of Rutland, who inquired if this was the man who had married the natural daughter of Lord Robert Manners and, being satisfied of this, secured his release. When the duke became Lord Lieutenant of Ireland in 1784, Hatfield followed him to Dublin and, by claiming a relationship with the viceroy, lived for a time in a suite of apartments at a hotel in College Green on credit. After one month the bill at the hotel amounted to over £60, and the landlord had him arrested, to be incarcerated in Marshalsea Prison in Southwark. The duke again came to his rescue, and he was released.

Incredibly, Hatfield continued his deceptions when he moved to Scarborough in 1792, claiming to still be of interest to the Duke of Rutland and that he would be one of the representatives in Parliament for the town. After a short time, his inability to pay for his residency at an inn led to his arrest at Scarborough on 25 April 1792. Jailed for more than seven years, somehow he managed to arouse the compassion of a Devonshire lady called Miss Nation, who lived with her mother in a house opposite the prison. She paid his debts and married him the next morning, on 14 September 1800. They moved to Dulverton in Somersetshire, where he managed to convince some highly respectable merchants in Devonshire to take him into partnership with them, and for a clergyman to accept his drafts to a large amount. He went to London once again and, at the general election, proceeded to canvass the rotten borough of Queenborough, but as suspicions rose he was declared bankrupt and disappeared, leaving his second wife and her young child in Tiverton.

In July 1802, Hatfield arrived at the Queen's Head in Keswick in a carriage under the assumed name Alexander Augustus Hope MP. He carried on with his *modus operandi* once more by living off the credit of a gentleman called John Crump. He also struck up a relationship with Mary Robinson, known as the 'Buttermere Beauty', daughter of the landlord of the Fish Inn at the picturesque lake of Buttermere. Obviously knowing Mary's family had some means, they were married at Lorton Church on 2 October 1802. News of the marriage of the 'Buttermere Beauty' to the Earl of Hopetoun, the head of the Hope family, was his undoing, as it was known that the real Colonel Hope was in Vienna at the time. After the wedding the couple had honeymooned in Scotland, so he was unaware he had been exposed. Upon his return from Scotland, he was challenged and committed to the

care of a constable. Somehow, perhaps by use of his proven powers of persuasion, he found means to escape, apparently taking refuge for a few days on board a sloop off Ravenglass and then by coach to Ulverston, and later seen in Chester. A reward of £50 was offered for his apprehension and a description was circulated. He was discovered in a village 16 miles from Swansea and committed to Brecon Jail, where he wore a cravat with his true initials 'JH', though he attempted to account for them by calling himself John Henry.

His trial took place at Carlisle at the Assizes for Cumberland on 15 August 1803. To three indictments for forgery, Hatfield pleaded not guilty. The jury returned a verdict of guilty, and he was sentenced to death.

On the day of his execution, 3 September 1803, the officials and the Carlisle volunteer cavalry attended the jail door at about 3.30 p.m. together with a horse-drawn carriage and a hearse. A great crowd had gathered as it was market day and curiosity had drawn many onlookers. The ever-vivacious Hatfield left the prison, wished all his fellow prisoners to be happy and bid farewell to the clergyman who attended him to the carriage. It was 4 p.m. when they set off from the jail and passed through the Scotch Gate, taking about twelve minutes to arrive at the Sands. The procession was attended by the yeomanry. Upon their arrival on the execution ground they formed a ring a round the scaffold. Stepping out of the carriage with his attendants, he would have seen a cart had been positioned under the gibbet and a ladder placed on the stage, and to this he immediately ascended. He untied his neckerchief and placed a bandage over his eyes. Apparently he requested the hangman to be as expert as possible about the task ahead, and he would wave a handkerchief when he was ready. The hangman had not fixed the rope in its correct place, so Hatfield put up his hand and turned it himself. Then he asked the jailer to tie his arms closer to his body, saying that if he lost his senses he might attempt to move them to his neck. Everything was made ready for and he exclaimed, 'May the Almighty bless you all.'

Though the noose had slipped twice and he only fell about 18 inches at first, he then dropped. As his feet almost touched the ground, his excessive weight swiftly eased him from any pain. He died in a moment and without any great struggle.

Mary Robinson and her bogus lover became the subject of novels, verses, dramas and tales. At the time Samuel Taylor Coleridge raised the profile of John and Mary's elopement when he published five articles for *The Morning Post*. Coleridge is also said to have visited Hatfield as a condemned man while travelling through Carlisle, attended by no less than Dorothy Wordsworth and William Wordsworth. Dorothy Wordsworth says in her letters that Coleridge did see the rascal in Carlisle. The reason Hatfield avoided Coleridge in Keswick was 'Hatfield was pretending to be a Devonshire man, and he knew that Coleridge, being from Devonshire, would detect his deception by his speech alone'.

In the end, with his demise, Hatfield became the important man he always seemed to desire.

Revd George Braithwaite

Revd George Braithwaite of Carlisle was believed to be 110 years old at his death in 1753. He was said to have been a member of the cathedral for more than 100 years, having commenced as a choir boy in the year 1652. He was said to be a curate of St Mary's when he died on 16 December.

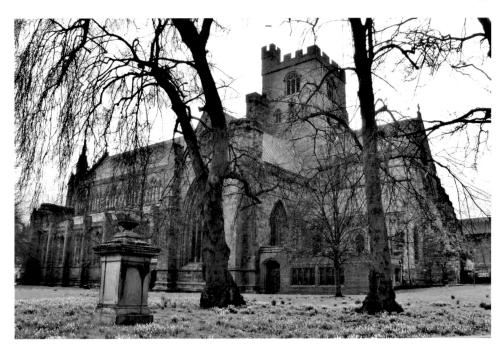

Carlisle Cathedral.

John Bell (1747–98)

John Bell was born in Carlisle in 1747, the son of a hatter. He joined the artillery in 1765 and became an artillerist and inventor. While at Southsea in 1782, he was an eyewitness to the foundering of the *Royal George* and devised a plan for destroying the wreck, which was carried out by Colonel Pasley in 1839. He also invented the 'sunproof' for testing the soundness of guns, which was used by the Royal Arsenal for many years.

He invented a 'gyn' (an improvised three-legged lifting device used on sailing ships) known as a Bell's gyn, which was lighter weight and less powerful than the Gibraltar gyn. It was often used by the British army for lifting artillery pieces. He also invented a petard, of which there is a model in the Woolwich laboratory; a crane for descending mines; a harpoon for whales; and an apparatus for rescuing shipwrecked mariners. He received various prestigious awards for some of these inventions.

In 1793 the Duke of Richmond gave him a commission as second lieutenant in the artillery, and in 1794 he was promoted to a first lieutenancy. He was employed in a secret expedition for the destruction of the Dutch fleet, but the operation was abandoned.

He died of apoplexy (a stroke) at Queensborough on 1 June 1798 while he was engaged in fitting out fire ships.

Joseph Stephenson (1756–92)

Joseph Stephenson was a portrait and landscape painter born in Carlisle who may have been baptised at St Cuthbert's on 2 February 1756. It was reported that from an early age he was 'dogged by illness'. He exhibited portraits at the Royal Academy in 1785 from Brown Street, Grosvenor Square, a prestigious address in London. He returned to Carlisle, where he practised as a landscape painter, dying at the young age of thirty-six after a long illness. His work was included in the Carlisle exhibition of 1823 where the *Westmorland Gazette* reported: 'The late Joseph Stephenson, a native artist also and likewise self-taught ... We understand that Mr Stephenson was a student of the Royal Academy'.

John Peel

Is 'D'ye ken John Peel' the song of Cumbria as 'On Ilkla Mooar Baht 'at' is the song of Yorkshire? Originally written by John Woodcock Graves in around the 1820s, the words were set to the tune of a traditional border rant called 'Bonnie Annie', and the most popular arrangement of it in Victorian times was William Metcalfe's version of 1868. He was an organist and choirmaster of Carlisle Cathedral, and his more musical arrangement of this traditional melody became popular in London and was widely published. However, in 1906 the song was included in *The National Song Book* with a tune closer to 'Bonnie Annie', and that is the most widely known version today. Graves immigrated to Tasmania where, before he died in 1886, he had described how the song was written. He explained that when in Caldbeck in 1828–29 his grandmother was singing his eldest son to sleep with 'Bonnie Annie' and led him to work out the opening line: 'D'ye ken John Peel, with his coat so gray.' John Woodcock Graves lived in the area, hunted with John Peel and must have had his name in his mind as he wrote the words.

John Peel was born at Greenrigg, a small hamlet near Caldbeck, in around 1776 or 1777. He is known to have kept hounds and hunted foxes as well being a farmer and dealing in horses. Aged twenty he fell in love with the eighteen-year-old Mary White from Uldale and put up the banns in Caldbeck Church, but Mary's mother forbade the banns, stating they were too young to wed. John borrowed his father's fleetest horse and eloped with Mary, taking her from her window at midnight and setting off for Gretna Green to be married. The marriage was given the Church's blessing at Caldbeck on 18 December 1797, and is recorded in the parish register. They had seven daughters and six sons.

Said to have been a great huntsman, living among the Cumberland fells and dales where he hunted his pack, his appearance is described in various accounts as a man of over 6 feet with his 'frame erect and powerful' with well-chiselled features and sparkling blue eyes. His wife later inherited a small property at Ruthwaite, near Ireby, and there they resided from 1823 until John Peel died on 13 November 1854. He was buried in Caldbeck Churchyard and his funeral was attended by around 3,000 people. Mary died five years later and was laid beside him, followed later by eleven of their thirteen children.

Robert Bowman

Robert Bowman of Botcherby, though blind from his infancy, made considerable progress in mathematics as well as other sciences and branches of literature. A student of John Howard, also brought up in Carlisle and a master at the Carlisle Grammar School, considered Bowman 'a rare instance of genius: he is a perfect master of the higher branches of the mathematics'.

William Hunter

On 14 November 1887 William Hunter, a travelling blacksmith and vocalist, was executed at Carlisle for the murder of a girl about four years of age. Originally from Glasgow, Hunter had been working as a blacksmith in Manchester but was 'tramping' from Wigton to Carlisle with Mary Steele and her daughter, Isabella. Hunter already had a wife in Manchester but had been with Mary Steele for the last three months. As they were moving towards Carlisle Isabella told Hunter she was tired of walking, so he told her to come to him, but she refused. Angrily, he strode up to her, grabbed her by the throat and then kicked her. The mother, screaming at him, shouted he had better not hurt her 'wee-un'. He then proceeded to carry Isabella into a field where he said he would revive her with water. The girl's body was later found dead. Hunter had cut her throat with a pocketknife. He

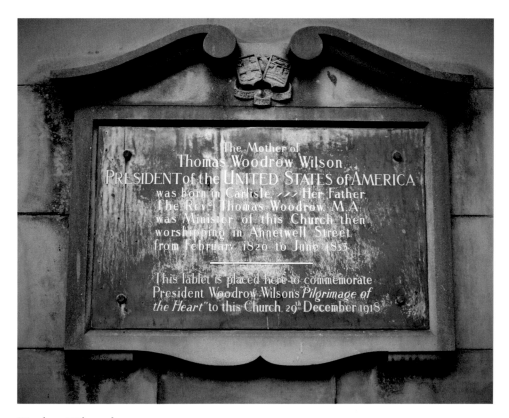

Woodrow Wilson plaque.

was tried at the Carlisle Assizes, and as the judge passed sentence, Hunter's wife, who had made the journey up from Manchester to offer her support, collapsed in the court. She was carried outside and later discovered that someone had picked her pocket and stolen the money her friends had clubbed together for her expenses. William Hunter was only thirty-two years of age.

Joseph Byrnes

Joseph Byrnes, a police constable, was murdered in the line of duty at Plumpton on 29 October 1885, where he was following up on the jewellery robbers of Netherby Hall – four notorious criminals who had planned to burgle the hall near Carlisle, all members of a successful 'ladder gang'. They were known as Anthony Benjamin Rudge, John Martin, James Baker and William Baker.

On 27 October 1885, Rudge, Martin and James Baker arrived at Gretna station where they left three cases in the care of the stationmaster. The next day Baker collected one case and joined the other two men in the Graham Arms Inn, close to the station. Later that afternoon, Baker returned and asked the stationmaster to forward the case to 'A. Smith, Carlisle Station, until called for'.

Knowing the family at Netherby Hall were in residence, they entered the grounds and got into the house without being seen. A housemaid discovered the door of Lady Hermione Graham's room was locked and she gave the alarm. A butler entered the room from outside and discovered that valuable jewellery was missing. The law was alerted and all the roads in and out of Carlisle were watched. The burglars were first seen near Kingstown a day later, and when challenged by the police, shots were fired in retaliation and the constables were wounded. The burglars made their getaway on a rail line heading towards Carlisle.

Later that evening, PC Handley stopped four strangers at Gosling Dyke, but one man pulled out a gun and Handley was compelled to let them pass. At 2 a.m. on 29 October, a signalman at Dalston Road crossing on the North Eastern Railway heard footsteps crunching on the ballast and saw men following alongside the line towards Carlisle. He opened his cabin door and, as he did, they made off. The signalman reported what he had seen to PC Fortune, who went in pursuit but was attacked by the men, who beat him with sticks and pistol butts before they headed for the road. PC Fortune recovered consciousness after half an hour and made his way, with difficulty, to the signal box. Two of the men were next seen in a goods yard near Carlisle and sometime afterwards a blood-stained jemmy was found in a wagon at Blencowe.

They were not seen again until the evening, when the stationmaster at Southwaite station was approached by a man who asked the time of the next train to London. The stationmaster told him the timings and the man replied that it was too long to wait. The stationmaster was somewhat suspicious and reported accordingly. Later, the stationmaster at Plumpton saw three men on his station and sent for the local constable, PC Byrnes. Byrnes went in search of the men. Shortly after, a shot was heard nearby. Within half an hour PC Byrnes was discovered with a gunshot to the head. Bloodstains and other traces indicated that he had been rolled down the bank. Byrnes died shortly afterwards.

The search continued and news came in after 10 p.m. when a constable on duty near Penrith saw three strangers behaving suspiciously. He lost sight of them in the darkness. A goods train due to leave Keswick Junction was searched without revealing any sign of the men. The guard, Christopher Gaddes, was advised to keep a sharp lookout. As his train moved off, Gaddes saw three men break cover and climb into a truck. When the train pulled up, Gaddes spoke quietly to a platelayer, who was near his van, and all available railway staff were mustered and armed with every weapon they could lay their hands on. Gaddes then jumped from truck to truck. He was not certain which truck the men were in, and he stepped on the back of one of them. All three jumped from the train and a desperate struggle took place. Martin broke away, but an engine driver managed to chase and hold him, although he himself was badly injured in the process. A revolver was found in Martin's possession. Rudge was also caught after a chase and violent struggle, and he too was carrying a revolver. Both guns had been fired recently.

James Baker escaped and hid in another truck. Near Oxenholme, two footplate men saw him leave the train and they passed the word on. Later, at Lancaster station, Baker was challenged by a guard. After a severe struggle Baker was secured, though his clothes were bloodstained. The fourth man, William Baker, had not been seen with the other three for some hours and he was not with them when PC Byrnes was murdered – a fact that saved his life. He was later arrested in Manchester and taken back to Carlisle where he received a sentence of penal servitude.

In January 1886, the three men were found guilty and sentenced to death to be hanged at Carlisle in February. On the scaffold, Martin confessed that he fired the shot that killed Byrnes.

Joseph Byrnes memorial.

A memorial was erected to PC Byrnes near the spot where he died. The inscription reads: 'Here Constable Joseph Byrnes fell on the night of October 29, 1885, shot by the three Netherby burglars whom he singlehanded endeavoured to arrest.' Above the inscription is a cross with the words 'Do or Die'. A constable cannot do more than that.

Joesph Bell

Joseph was born in Farlam but moved to Newcastle, where he served his engineer apprenticeship. He was hired by the White Star Line and served on several ships before being appointed to his post on the *Titanic*. After the fatal collision, he and his colleagues struggled to keep the lights, pumps and radio working until minutes before the ship finally sank. He and his fellow engineers saved many lives because of their heroism and bravery on that tragic night. As reported by the British Transport Police Crime History:

Joseph Bell

A Memorial gravestone in St Thomas a Becket Churchyard at Farlam, just south of Brampton, bears the message below.

> JOSEPH BELL AGED 51 YEARS SON OF THE
> ABOVE MARGARET BELL CHIEF ENGINEER OF
> THE SS TITANIC WHO WAS LOST WITH ALL
> HIS ENGINEERING STAFF IN THE FOUNDERING OF
> THAT VESSEL IN THE ATLANTIC OCEAN
> AFTER COLLISION WITH AN ICEBERG

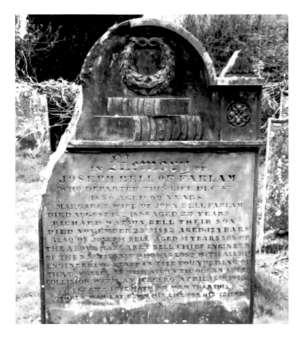

Joseph Bell's gravestone.

APRIL 12TH 1912
NO GREATER LOVE HATH MAN THAN THIS.
THAT A MAN LAY DOWN HIS LIFE FOR
HIS FRIENDS

John Vernon Addison

John Vernon Addison OBE was a journalist who was born on 2 May 1930 and educated at Barnard Castle School. He started his newspaper career in his native North East in 1956 before moving to Manchester as a sub-editor on *Manchester Evening News*. He then went on to become sport sub-editor in the Manchester office of the *Daily Express* but moved back a year later to the *Manchester Evening News* for the next sixteen years, becoming assistant editor. He was appointed editor of the *Cumberland News* and the *Evening News & Star* in Carlisle in 1976, before retiring as editorial director of *Cumbrian Newspapers* in Carlisle in 1990.

During his career he received several notable awards and titles including becoming member of national council and chairman of the north-west region 1981–82. He also did public relations consultancy work after retiring, including for Pioneer Foodservice and the Christopher Harrison Group. He was the founder chairman of Carlisle Jazz Club, dedicated fundraiser for Cumbria Cerebral Palsy and wrote his family history in *Black Sheep and Diamonds*. He died at Cumberland Infirmary, Carlisle, on 24 December 2016 aged eighty-six, with funeral at St Michael's Church, Dalston, on 6 January 2017.

Francis Percy Toplis

Francis Percy Toplis is a well-known character due to dramatisation of his story as 'The Monocled Mutineer', which portrayed him more as a hero than as the brigand he seems to have been in real life. He is buried in an unmarked grave at the Beacon Edge Cemetery, near Penrith. Francis Percy Toplis was killed on the road between Carlisle and Penrith in 1920. He was the subject of a book in 1978 which was adapted for television by Alan Bleasdale in 1986.

He was raised in Derbyshire by a succession of family members and was known as an unruly child, often in trouble and was even birched aged eleven. He left school at the age of thirteen to become a blacksmith's apprentice but was soon dismissed and began to travel around partaking in petty crime. In 1912, aged fifteen, he was sentenced to two years' hard labour for the attempted rape of a fifteen-year-old girl at Mansfield, serving his sentence in Lincoln Prison.

Following his release from prison, he joined the Royal Army Medical Corps (RAMC) and served as a stretcher bearer until 1915 when they became part of the force sent to Gallipoli. The campaign was an utter disaster and conditions were horrific, and when they returned Toplis was hospitalised with dysentery. He was given light duties in a munitions factory at Gretna before being posted to Salonika and Egypt where he contracted malaria and had to be shipped home. In September 1917 his unit was shipped to Bombay for some months and then returned to Britain.

A television production from 1986, *The Monocled Mutineer*, portrays him as hero of a riot that broke out among British troops in September 1917, during the First World War,

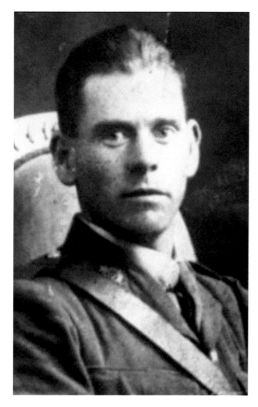

Francis Percy Toplis.

near Étaples, in France. However, in reality Toplis was not even near the area depicted and the work is considered pure fiction. To be fair to the authors and production teams, there were a few soldiers at the time with the name Toplis and the story seems to connect them together.

Toplis was stationed at RAMC Blackpool but deserted shortly after the death of his father in August 1918. At Nottingham Assizes he was sentenced to two years' imprisonment for fraud, yet when he was released in 1920 he was allowed to join the Royal Army Service Corps and was stationed in Bulford, near Andover. He was soon up to no good, selling black market army fuel, forging false papers and wearing a colonel's uniform when he visited women in town. To complete his deception, he would often wear a monocle – the reason for the literary nickname.

Toplis deserted again, but this time a taxi driver was found shot dead on Thruxton Down, near Andover, and Toplis was accused of the murder. At twenty-three years of age he was on the run once again, this time heading to Scotland. After a spell of cold weather, he lit a fire in a remote gamekeeper's cottage. The smoke was seen by a hill farmer, who returned with the gamekeeper and the police. Toplis took out a revolver and fired several shots, wounding them, before escaping on a bicycle. He abandoned the bike at Aberdeen and travelled south by rail via Edinburgh, eventually arriving in Carlisle on 5 June. At Carlisle, he reported to the guardroom at the barracks, posing as an escort who had lost his prisoner.

Wife and mother of Toplis.

The next day he was spotted sitting beside the Carlisle to Penrith road near Low Hesket by PC Alfred Isaac Fulton. The chief constable authorised the arming of two police officers and sent his adventurous son to go with them to arrest the suspect. The armed police hid behind a farm wall on the A6. Toplis was challenged by the police, and then, following an exchange of gunfire, he was shot and fatally wounded as he tried to run away.

Among his possessions was the monocle he wore to impress the ladies. To help pay for the cost of his burial this, along with his other belongings, was handed to the Penrith Board of Guardians. Luckily, Councillor Johnstone, a member of the board, was also a member of the Penrith Urban District Council Historical Committee and the items were handed over to the Penrith and Eden Museum.

Edward Courtney Boyle (1883–1967)

Edward Courtney Boyle VC was born in Carlisle. He was awarded the Victoria Cross on 21 May 1915 when submarine HMS *E14*, of which he was commander, dived under a minefield to reach the Sea of Marmara and sank two Turkish gunboats. There is a plaque on his birthplace in Chatsworth Square, Carlisle.

He was the son of Lieutenant Colonel Edward Boyle, who served in the army's Pay Department, and Edith (née Cowley). Educated at Cheltenham College, he entered HMS

Britannia in 1897 and became a midshipman the following year. He was an early pioneer in the navy's Submarine Service and was considered for command of a Holland Class submarine as a twenty-one-year-old sub-lieutenant. The Holland Class submarines were the first such vessels built for the navy – confidence must have been high in the young man's abilities.

Promotion followed at regular intervals until the outbreak of war, when he was captaining *D3* in the 8th Submarine Flotilla. His early North Sea patrols, which included what Admiral Keyes described as a 'first class daring reconnaissance' into the shoals inside the Amrum Bank off the north German coast, were recognised by a mention in despatches. He was promoted to lieutenant commander and given command of the *E14*, one of the navy's latest submarines. The following March, *E14* was among three E Class boats sent from England to operate in the Dardanelles.

During this operation he took *E14* and dived under enemy minefields to enter the Sea of Marmora on 27 April 1915. Despite great navigational difficulties from strong currents, the continued threat from hostile patrols and the incessant danger of attack from the enemy, he continued to operate in the narrow waters of the Straits and succeeded in sinking two Turkish gunboats and one large military transport.

Over five months, Boyle and his crew completed three successful cruises into the Sea of Marmara, with each spell in the Dardanelles becoming more dangerous than the previous one by the strengthened and more aware Turkish forces. On the return passage, after his third patrol, they came extremely close to disaster, when they burst through a new anti-submarine net, narrowly escaping being hit by two torpedoes fired from the shore. They had spent seventy days in the Marmara and shortly afterwards, the *E14* and its captain were withdrawn from the area.

Boyle's services were recognised by the Royal Navy, who promoted him to commander. The French and Italians also gave him decorations: the Chevalier of the Legion of Honour and the Order of St Maurice and St Lazarus. The Victoria Cross was awarded for the first patrol and, though he continued to serve in submarines throughout the war, he received no further awards from his own country.

After the war Boyle mixed shore duties with seagoing commands, including the cruisers HMS *Birmingham* and *Carysfort*, as well as the famous but aging battleship *Iron Duke*. He also served as the King's Harbour Master at Devonport before being promoted to Rear Admiral in October 1932, after which he retired on a Good Service Pension. During the Second World War he served for a time as flag officer.

He died on 16 December 1967 because of injuries sustained the previous day when he had been knocked down by a lorry on a pedestrian crossing. He was cremated at Woking Crematorium, Surrey. The family presented his Victoria Cross to HMS *Dolphin*, now at the Royal Submarine Museum, Gosport, Hampshire.

Derek Batey

Derek Batey was a well-known and popular TV presenter for many years. He born at Brampton, near Carlisle, and was educated at the White House Grammar School. In 1940, he bought a ventriloquist's doll for three guineas and called him Alfie. He practised a ventriloquism act and after leaving school in 1944 to work at a firm of accountants, he

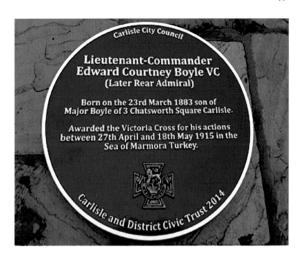

Edward Courtney Boyle plaque.

continued with ventriloquism shows several nights a week. He got his first break when he was booked by the BBC to perform his ventriloquism act, implausibly, on local radio. He later became a radio reporter and moved to television in 1957 to be a regional compare on *Come Dancing*. In 1960 he moved to the newly launched Border Television where he produced and presented several programmes. He is best known for the long-running late 1970s to late 1980s show *Mr and Mrs*.

William Armstrong

Border reivers have had many ballads and stories written about them, and Armstrong is a name that crops up regularly. William Armstrong (aka Kinmont Willie) was around from about 1550 until 1610. He lived at the Tower of Sark, which had been built by his father in the lands of the English–Scottish border and was named after the adjacent River Sark.

At the time of discord between England and Scotland following the escape and imprisonment of Mary, Queen of Scots the borderers were caught between the quests for power by their overlords, who fought against one another for political ends. Law and order had all but broken down, and the borderers themselves made the most of it, where possible, for their own gain. The Armstrongs occupied great swathes of land around Bewcastle, Kirklinton, Eskdale and Liddesdale. After a series of raids, thefts and broken truces, William Armstrong became one of the most wanted men in the region. Lord Scrope requested help from the crown to deal with the Armstrongs and Elliots. Scrope asks for 100 horsemen and their pay to prevent the attacks. He specifically mentions Kinmont Willie, his sons and accomplices as continually being in the company of the Scottish warden and therefore never prosecuted for their offences against England.

In one attack, attended by over 200 men, known as 'Kinmont's bairns', it is claimed that in north Tynedale they took away 400 cows and oxen, 400 sheep and goats, and 30 horses and mares. They took the contents of the houses to the value of £200, killed six people and wounded eleven. Thirty prisoners were taken, and ransoms demanded.

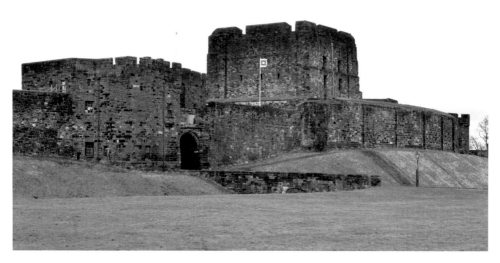

Carlisle Castle keep.

William was captured in 1596 by Thomas Salkeld on a day of truce and was taken in chains to be imprisoned in Carlisle Castle. He was soon broken out by Walter Scott of Buccleuch, who was annoyed by this violation of the customary day of truce. He continued his raids and in 1600 attacked the village of Scotby with 140 raiders. His last foray was said to have been south of Carlisle in 1602. It is thought he died between 1608 and 1611. His tomb may have been identified at Morton Kirk, near his Tower of Sark. His sword is believed to be the one at Annan Museum.

DID YOU KNOW?
Woodrow Wilson, who served as the 28th President of the United States, came to Carlisle as part of his 'Pilgrimage of the Heart' to visit the area where his mother was born.

3. Buildings and Places

Roman Bathhouse

A Roman bathhouse of some splendour was discovered at the Carlisle Cricket Club in 2017; archaeologists have suggested the findings could indicate that Emperor Lucius Septimius Severus may have visited the site. The excavations have found a set of significant artifacts, including weaponry, jewellery and imperial-branded tiles. Speculation by the team proposed this was a working bathhouse or civic building that was commanded by the emperor himself. It was probably the main meeting place for the elite Ala Petriana cavalry soldiers, whose fort was at Stanwix. This cavalry unit was considered a ruthless and skilled fighting entity, possibly 1,000 strong, and a rapid response force useful for protecting the expanse of the Roman Empire's northernmost frontier. As the bathhouse is so close to the Stanwix cavalry fort, it would have been where the men relaxed, bathed, socialised and gambled, which would account for the considerable number of Roman coins found at the site.

River Eden.

Bewcastle Cross

The pillar or cross at Bewcastle, near Brampton and Carlisle, is considered to be from the mid-seventh century and was possibly erected over the grave of Alfrid, or Alcfrid, who became King of Deira around 650. Located within the churchyard of St Cuthbert's in Bewcastle, the body is highly decorated and full of runic inscriptions. Various translations of the inscriptions exist, but the one considered the most accurate is given by Revd H. D. Haigh: 'This beacon of honour set by Hwastred, in the year of the great pestilence, after the ruler, after King Alcfrid. Pray for their souls.'

Bewcastle was once a Roman station and is thought to have later been a Saxon royal residence. After the Norman Conquest, a castle was built in the north-east corner of the Roman fort. During the reign of Edward I, a church was built using the stone from the Roman fort and Norman castle. In the eighteenth century, the church was rebuilt and the dedication changed to St Cuthbert. Many Roman inscriptions have been found here, as well as coins, jewellery and many other objects. One story tells of a gold ring found in the garden of the manor house, which was given to the daughter of a local farmer.

Carlisle Castle

As with a great many Norman castles in the north, the castle at Carlisle is built over part of the Roman one (look at the castles at Bowes, Brough and Brougham along the A66 as

Bewcastle Cross.

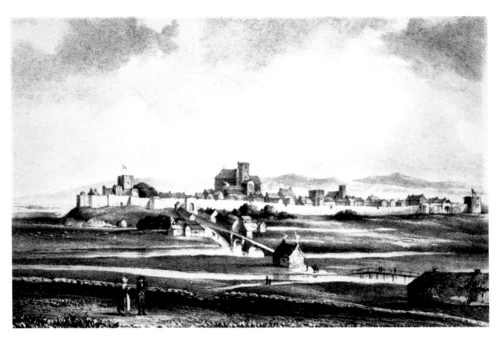

View of Carlisle from the north.

examples) and this is probably for two reasons. Firstly, the position of the Roman fort would have been chosen for strategic reasons. The site is protected by the rivers Eden and Caldew, which also offer a water supply, and the Normans would have known this. Secondly, it would make sense to reuse some of the building materials and ditches from the Roman fort to build and protect the new castle. When William II succeeded his father, 'the Conqueror', in 1087, Cumbria was part of the kingdom of Galloway and Strathclyde under Scottish influence. Taking advantage of a Norman feud between William and his brother, Robert Curthose, the King of Scotland, Malcolm III, had invaded northern England until William, at the head of an English army, pushed Malcolm back in 1091, forcing him to pay homage. The following year the William invaded Cumbria to take out Malcolm III's retainer, a powerful Anglo-Saxon noble called Dolfin. To take control of the region, William instigated the building of a castle at Carlisle and imported English settlers to entrench English power in the north:

> In this year king William with a great army went north to Carlisle and restored the town and built the castle; and drove out Dolfin, who ruled the land there before. And he garrisoned the castle with his vassals; and thereafter came south hither and sent thither a great multitude of [churlish] folk with women and cattle, there to dwell and till the land.
>
> The Anglo-Saxon Chronicle

It is thought the first castle may have been a simple ringwork, using the natural slope to the north and a deep ditch cut as a defence to the south. It may have also reused the remaining Roman defences to bolster the new castle. Henry I visited Carlisle in 1122 and ordered that

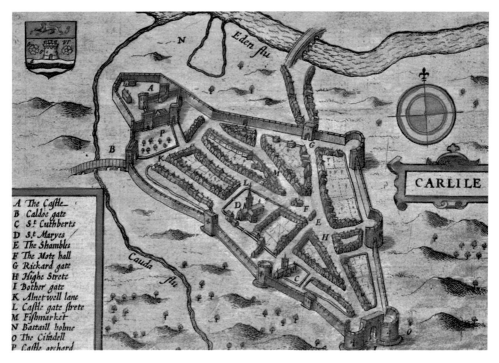

A The Caftle
B Caldoe gate
C S.t Cuthberts
D S.t Maryes
E The Shambles
F The Mote hall
G Rickard gate
H Highe Strete
I Bother gate
K Alnetwell lane
L Caftle gate ftrete
M Fifhmarket
N Battaill holme
O The Citadell
P Caftle orchard

An old map of the castle and city walls.

it be 'fortified with a castle and towers' and it is thought this order started the building of the keep. The castle works were still in progress in 1130 and after Henry I's death in 1135, Carlisle was retaken by David I, King of Scotland, who is said to have built 'a very strong keep' there. It may be that David I completed the keep, but it was for the purposes of defending against any English counterattack. David died in Carlisle on 24 May 1153, aged approximately seventy-three, before being taken to Dunfermline Abbey to be buried. His grandson, Malcolm IV, took the crown, but in 1157 Henry II summoned Malcolm to meet him at Chester. He signed the Treaty of Chester, where Malcolm relinquished his claims to Northumbria, Cumberland and Westmorland, including Carlisle.

Henry II visited Carlisle in 1186 and ordered further alterations to the castle complex, including buildings of the inner ward. Later, under King John in the early thirteenth century, it is believed an outer curtain wall was added. During Edward I's campaigns against the Scots in the late thirteenth century, he instigated further modifications and a residential tower to be built to improve the comfort of the accommodation and bring the castle up to date.

Following the victory over the English at the Battle of Bannockburn, Robert the Bruce besieged the castle but failed due to an interesting character called Andrew Harclay mentioned earlier in this book. Harclay was rewarded by Edward II and made Earl of Carlisle in 1322. There was another siege in 1461 during the Wars of the Roses when a combined army of Lancastrians and Scots took the castle from the Yorkists. The siege included the early use of gunpowder weapons. It would be the onset of gunpowder

weaponry that would make traditional castles obsolete over the following years, but it was not until 1541, under the direction Henry VIII, a Moravian engineer called Stephan von Haschenperg was employed to make significant changes to the defences. The keep was lowered and an artillery platform was added to the roof, the inner ward walls were strengthened, and the half-moon battery was erected. The battery was originally higher so the soldiers could shoot out over the outer ward, but it was levelled in the nineteenth century.

The castle was further used to house border reivers, Mary, Queen of Scots, Civil War prisoners and Jacobite rebels under Bonnie Prince Charlie. The castle was later used as a military garrison and an army barracks before eventually becoming an English Heritage site, the centre for county's emergency planning services and Cumbria's Museum of Military Life. A visit to the most frequently besieged place in the British Isles is highly recommended.

Inglewood Forest

Inglewood Forest lies between Carlisle and Penrith. It was established shortly after the Norman Conquest, when it became a royal forest. The term refers to an area of land set aside for hunting by the local lord with royal consent and did not necessarily need to be a wooded area. The name Inglewood Forest means 'Wood of the English/Angles'.

The area measures about 60 miles in circuit and was given by William the Conqueror to Ranulph de Meschines as the Earl of Cumberland. He divided the county into eleven baronies: Copeland, Allerdale below Derwent, Wigton, Burgh, Dalston, Greystock, Gilsland, Crosby, Liddell and a nameless barony in the south-east part of the county, under the fells, given to Adam FitzSwein. He reserved the forest of Inglewood for himself. The full extent of the forest stretched from the walls of Carlisle to the town of Penrith; it included the poorly drained area of land between the rivers Eden and Petteril and west to the Cumbrian Fells. The forest was well stocked with red deer, fallow deer, wild boar and many other beasts of chase.

From the reign of Henry I, king from 1100 to his death in 1135, the forest was reserved as a royal hunting ground. Subject to forest law, no man was allowed to hunt or take game or in any way abuse the forest. Only under licence could a man living within a forest cultivate or enclose land, or build, hedge, ditch, drain, cut down trees or even collect firewood. He could not hunt deer, wolf, boar or even the smaller animals, or cut down a bush which might give food or shelter to a deer. Under Henry I it was forbidden to have dogs or bows and arrows in the forest without a warrant. Rights were granted to graze pigs, as at Mungrisdale, or to feed cattle, as at Stockdalewath, but there was very little settlement.

When Edward I resided in Carlise, he would hunt at Inglewood. It is recorded in the eighth year of his reign that 'he hunted for four days, and on the first there were killed four hundred harts and hinds'. In 1391, after another great fire in Carlisle, Richard II gave 500 oak trees from the forest to rebuild the city. Even the Bishop of Carlisle had to pay half a mark a year to graze his cattle. Successive kings kept Inglewood Forest underdeveloped so that it served as a 'buffer zone' between the Scottish border and England. This led to Carlisle being cut off economically from the rest of the country and the sparsely populated forest became a place of legend and romance.

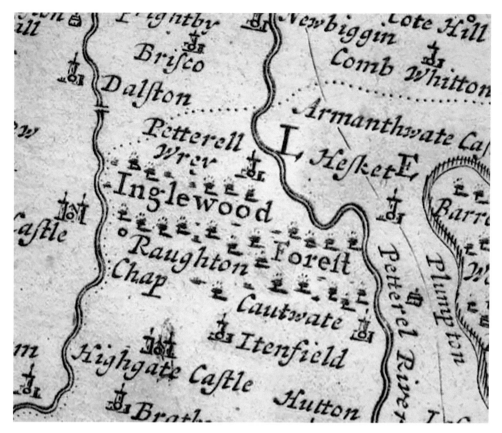

Inglewood Forest.

Tarn Wadling was a small lake near High Hesket. It is now drained but was at the centre of many legends. In the Middle Ages it belonged to the nuns of Armathwaite, and the Augustinian canons of Carlisle also had fishing rights there. It had a magical and mysterious reputation. In the thirteenth century, Gervaise of Tilbury called it 'Laikibrait' or 'the lake which cries' due to an account of the peal of bells which could be heard every morning. In August 1810, a small island rose from the bottom, several yards in diameter, remaining several months before sinking again – much like Avalon or Brigadoon. More probable is the tarn originated as a post-glacial feature which filled with water and a build-up of rotting vegetation. From time to time, it may have emitted methane and caused strange sounds or the phenomenon known as will o' the wisp. The 'island' could have been a mass of vegetation breaking free and rising to the surface, then sinking down again. Lord Lonsdale had the lake drained in the nineteenth century and today it is no more than a shallow dip in the ground.

Another story tells of a giant living at nearby Castle Hewin (or Hewen). The castle was situated on the top of a ridge adjoining Aiketgate; according to Hutchinson, there were outer defences and long extended trenches. It is recorded as ruined by Leland in 1553 and by Hutchinson in 1794. Some think it may be an Iron Age fort, or even Roman.

In another medieval ballad a band of forest outlaws escape hanging in Carlisle and seek shelter in Inglewood Forest. Adam Bell, William Cloudsley and Clym of the Clough eventually secure a pardon from the king when William shoots an apple balanced on his son's head from sixty paces – a retelling of the William Tell story perhaps?

As the property of the crown, the area continued to be strictly under the forest law until the time of Henry VIII. It was given to the 1st Earl of Portland by William III. The whole area remained thinly settled and poorly utilised until the Enclosure Acts of the late eighteenth and early nineteenth centuries, when the fields were drained and the land was farmed more productively. The last 'gnarled and knotted' oak of Inglewood Forest, on Wragmire Moss, 'fell from sheer old age' on 13 June 1823. In 1973, Cumberland County Council preserved the 44 acres of Wreay Woods as 'one of the last remaining ancient woodlands on the river Petteril'.

St Nicolas Hospital
From around the time of King John there was a leper hospital along the southern entrance to the city, somewhere just south of South Street and around St Nicholas Street. The St Nicholas Hospital was sacked at various stages, including 1296 and 1338, and in 1393 a clerical commission reported neglect, corruption and overstaffing. There is now no trace of the buildings and nothing remains but the name of the district of St Nicholas in Botchergate. A Parliamentary survey of 1650 reveals that the hospital was completely destroyed during the siege of Carlisle in 1645. Burials have been found in the area beside the road on the south and east where the churchyard is said to have been. The area where the hospital and the graveyard stood is now covered with buildings and streets. The area is full of references to the old hospital in its street names, public houses and retail parks.

Carlisle Cathedral, St Mary's
When I visited Carlisle Cathedral I was impressed by its beauty; though the building is not of great size, the incoming natural light combined with the artificial light really brings out the features of this red sandstone house of worship. The cathedral also contains many treasures, carvings and artwork, but a visit to the crypt area reveals delicate silverwork and a chest with a lid that may be of a much earlier date.

St Mary's is the only cathedral in Cumbria. It was founded in 1122 but is thought to have been built on the site of an earlier Anglo-Saxon monastery. The Venerable Bede tells of St Cuthbert's visit to Carlisle in 685 when he was taken to see some Roman walls and a well. This visit may have instigated the building of a monastery complex, but in 875 it is believed Carlisle was destroyed by the Danes and that the town lay desolate until the Norman Conquest.

DID YOU KNOW?
There is a legend suggesting that the bowels of Richard I, 'the Lionheart', are buried at Carlisle Cathedral.

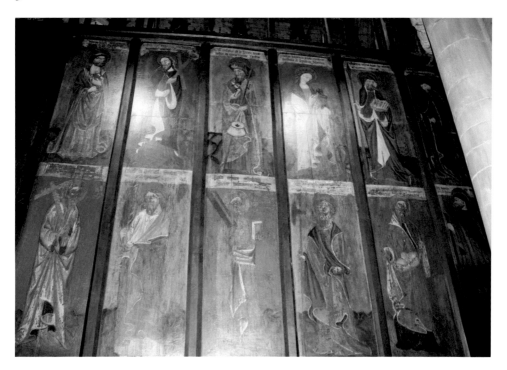

Painted screens at the cathedral.

The Normans built the priory church that was to become a cathedral in 1133. The cathedral buildings were damaged by fire in 1292 and suffered during the English Civil War, when much of the nave was demolished. The east window is one the finest examples of fourteenth-century stained-glass windows in the country, and beneath it is a piscina, an inset bowl where the priests would wash their hands. The painted screens in the aisles of the nave show scenes of the lives of St Augustine, St Anthony and St Cuthbert. Many places of worship in the country lost or had their screens destroyed during and after the Reformation. The chancel contains a fourteenth-century barrel-vaulted ceiling made from thin wooden planks. The ornate deep blue paintwork with sun and stars gilding decoration is exquisite. The associated fratry, built in the 1500s was the dining hall of the cathedral priory, and over the years it has been used as a kitchen, an arsenal, a brewery, granary and a library.

Outside the cathedral, high up on the side of the building, close to east window, is a gargoyle in the image of a policeman. Next to him is another one wearing glasses, a carving of the sculptor himself.

DID YOU KNOW?
Sir Walter Scott was married in Carlisle Cathedral on Christmas Eve 1797.

Guildhall.

Guildhall

One of the oldest buildings in the city is the Grade I listed Guildhall. Situated close to the marketplace, it would have been a meeting place for the city trade guilds. It was originally built as a residence and workshop sometime between 1377 and 1399 for Richard de Redness, who generously left it to the city in his will. Also at times known as Redness Hall, it is thought the present building replaced an earlier structure that was burnt down in the fire of 4 May 1391.

Much of the early timberwork survives, as do some wattle-and-daub internal walls. When the timber was dendrochronologically tested, it was all confirmed to date from the time the building was originally constructed. It is possible the lower floor was open and supported by wooden stilts, like many other buildings of this style in the country, and used as a covered market area. The building was extensively renovated in 1978–79.

The building is now occupied by a private business on the ground floor, but the upper floors contain a museum. The entrance and staircase to the museum are relatively modern and it is thought the original entrance was on Fisher Street.

Irish Gate

The city walls included various gates or entrances based on the road pattern at the time and, as with many walled towns, as horse-drawn coaches and motorised vehicles became

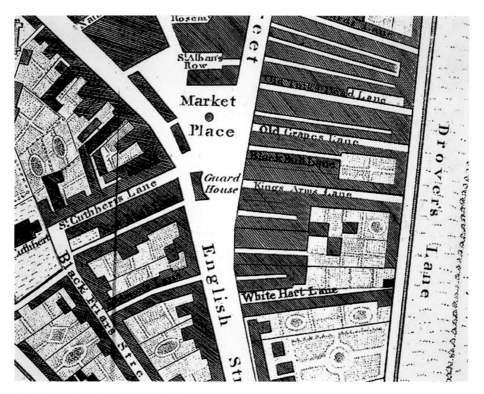

An old map showing the Market Place.

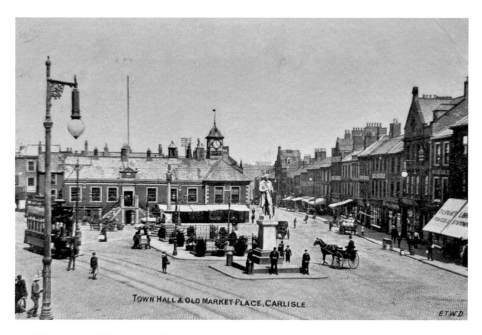

An old postcard of the Market Place.

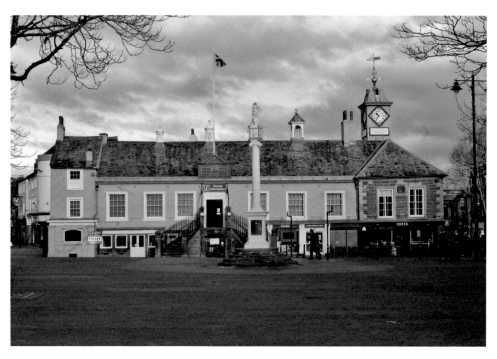

The Market Place in 2021.

the norm these narrow defensive openings were believed to strangle free movement. Many were demolished, forever lost to history. Such was the fate of the Irish Gate *c.* 1811. Today the gate is represented by a curving footbridge that spans the modern A595 to the north of Carlisle and a brick-built arch or tower over the pedestrian walkway. The gate was also known as the Caldew Gate and was connected to a bridge spanning the River Caldew. On the opposite site of the current archway, the dismantled end of the curtain wall is clear to see, as is the remaining west wall from the corner of the castle complex. These walls line up and the remaining west walls head to the south of the city.

When the Scots besieged the city in 1315 after the Battle of Bannockburn, Carlisle's walls were under attack, including the Irish Gate. The Lanercost Chronicle reveals that the Scots 'erected an engine and continually threw great stones towards the Caldew Gate, but did no injury'. Amazingly, some of these projectiles were found during building work on Annetwell Street in 1878. In 1385, it was reported to the crown that the Irish Gate would not shut properly; records suggest it took forty-three years for a grant of £80 to be made for its repair. Later, in 1563, the gate was recorded as being in a poor state again, so Colonel Thomas Fitch, Governor of Carlisle, ordered that the doors from a nearby demolished castle be hung in the Irish Gate.

The medieval wall follows the line of the Roman banks. William Rufus is reported to have begun the building in 1092, but it is more likely they were built in stone from around 1130. The original structure had a small barbican. This covered a drawbridge that spanned the city ditch or dyke, which probably surrounded the wall. The gate was said to be in good repair when Nathaniel Buck (the famed engraver and printmaker) visited in Carlisle

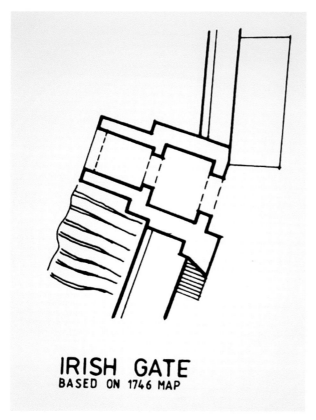

IRISH GATE
BASED ON 1746 MAP

Irish Gate plan.

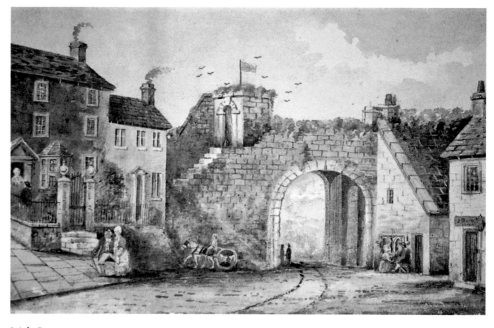

Irish Gate.

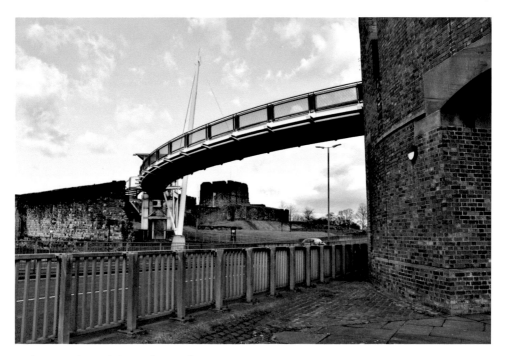

Irish Gate today and the modern walkway.

in 1738 to draw the walls and gates of the city. The current walkway and Irish Gate were constructed during the millennium and opened on 9 October 2000.

The Tile Tower

As mentioned earlier, the city walls date from the twelfth century and were built from sandstone blocks, some of which would have been retrieved from the existing Roman fortifications. The walls surrounded the old *vicus* or town that grew up around the fort, and towers were placed at intervals as guardhouses to gates or sections of wall. The towers project from the wall and allow the defenders to check the length of the walls for attackers. The Tile Tower is one of these interval towers and would have formerly guarded the Irish Gate. The rectangular tower, though part of the original twelfth-century fortifications, has been modified at different times from the fifteenth to the eighteenth centuries. Houses were built against part of the walls in the early nineteenth century and joist holes for floors can still be seen cut into the Tile Tower and wall. The last of these houses were demolished in 1952.

Other gates in the city walls include the sally port on the west wall, opposite St Cuthbert's, the English Gate at the Citadel and the Scotch Gate at the end northern end of Scotch Street.

The Citadel

By the time of Henry VIII the southern defences and entrance to the city were deemed insufficient and in need of strengthening. The crown identified Stephan von Haschenperg

Tile Tower.

as the man to update the castle and modernise the old southern point of entry to the city, known as Botcher Gate or English Gate. The Citadel was built in 1541–42 and consisted of a triangular enclosure with massive round towers situated at the angles. As the name suggests, the Citadel was designed to be independent of Carlisle's other defences and able to hold out to attack without the mutual support of some of the now obsolete defences of the city. It was also fortified on its northern side, the side facing into the city and a half round tower was constructed as an arsenal to ensure self-sufficiency during an attack.

Some remodelling of the old defences was carried out to allow for the installation of gun ports, replacing the old medieval-style defences. On the west side a rectangular tower was built to mount further guns on the defensive structure. To either side of the main entrance two large round fortifications were erected, which were of storeys and 60 feet in diameter with 12-foot-thick walls. Built within these were casemates mounting more artillery. The Citadel was connected by curtain walls. To allow passage to and from the city, a new gate (the English Gate) was included in the Citadel design. A few years after the accession of James I (VI of Scotland) and the unification of the Scottish and English crowns, the Citadel was mainly used as a gaol.

In 1810, the fortress was almost completely demolished to create the present complex, and only the lower level of the eastern tower remains. In the spirit of the Henrician complex, the new Citadel, designed by Thomas Telford and built by Sir Robert Smirke,

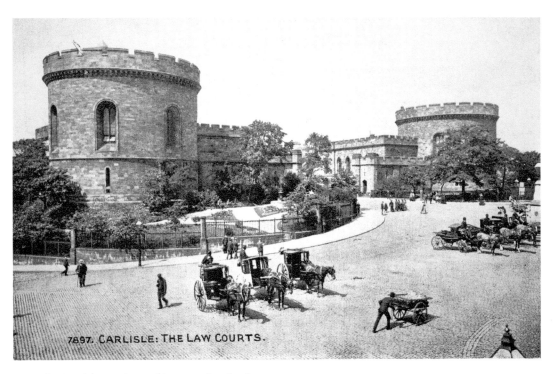

7897. CARLISLE: THE LAW COURTS.

The Citadel, seen in an old postcard and today.

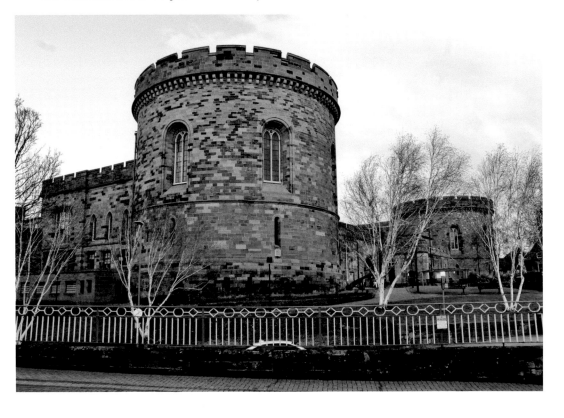

Dixon's Chimney.

followed a similar design with two massive circular towers constructed in red sandstone ashlar and battlemented parapets. The building also served as civil and criminal courts as well as the city gaol.

DID YOU KNOW?
Carlisle had the first postbox on mainland Britain – in Botchergate in 1853, on the corner between Botchergate and South Street.

Dixon's Chimney

When Peter Dixon and Sons Ltd built the Shaddon Mill in 1836 it was the largest in the country; the chimney, at 305 feet high, was the tallest in the country and the eighth tallest in the world. This huge seven-storey factory was so large it could not have been powered by water, so steam power was used from the beginning. The chimney, built by Richard Tattersall, has English bond brickwork with flush red sandstone quoins. It is an octagonal tapering shaft complete with iron tie-bands at the top and bottom. The internal diameter of the chimney measures 17 feet 6 inches, and it has 10-foot walls at the base.

In 1840 Dixons employed over 3,500 handloom weavers in England, Scotland and Ireland. At their peak, Dixons employed a workforce of 8,000. In 1883, Peter Dixon and Sons Limited went into liquidation and the mill was taken over by Robert Todd and Sons Limited, who then used the mill for wool production rather than cotton.

The chimney was damaged by lightning in 1931 and it was necessary to take off the top few feet in 1950 for safety reasons. Now standing at around 290 feet tall, it is still a popular and familiar landmark in Carlisle. It is so popular as a local landmark that when it was in need of repair in 1999 it was restored by Carlisle City Council.

Eden Bridge Gardens

For a long time the Italianate Gardens, known locally as the Chinese Gardens, lay abandoned and unloved. Located on the north bank of the River Eden, just to the north-east side of Eden Bridge, these gardens were designed by the internationally renowned Kendal firm of landscape gardeners Thomas H. Mawson & Sons. Mawson was famed for his grand Italianate designs, many of which still exist at stately homes, including Rydal Hall in Cumbria.

Built using unemployed labour during the Depression of the 1930s under the supervision of Percy Dalton (borough surveyor), the gardens cost just over £3,000, with the cost being kept down by using reclaimed materials. The white cove stone used to make the rest houses was taken from the old Eden Bridge parapets that were demolished during the

Dixon's Chimney at dusk.

Shaddon Mill.

Eden Bridge Gardens.

bridge-widening operations of 1930 to 1932. The sandstone used to build the retaining walls was taken from the old gaol in English Street, and the crazy paving that runs throughout the garden was taken from the old road, which used to pass over Eden Bridge.

The design features pergolas and raised terraces overlooking lily ponds. There is a rock garden and crazy paving to the surrounding walkways. As Thomas was suffering from Parkinson's disease at the time much of the work is attributed to his son, Edward. Thomas died in November 1933. The gardens were opened in 1933 by the city mayor, Councillor E. B. Gray.

The gardens fell into disrepair but were restored to their former glory by the Carlisle City Council following a grant from the Lottery Fund in 2008.

Port Carlisle, Canals, Railways and Dandy Cars

Not a great deal remains of this short-lived venture, but Port Carlisle was a solution to the growth of industry in the early nineteenth century and the inadequate roads available for bulk movement of materials. From 1807, various plans were submitted by some of the great canal engineers of the time, but with no agreement as to the best scheme, the decision was deferred for ten years. In 1818, the route was agreed from Fisher's Cross, near Bowness (renamed Port Carlisle), to Carlisle. Work started on the canal in 1819, with the canal basin close to where Carr's biscuit factory is. The canal opened in 1823 and was 11.75 miles long, with eight locks to accommodate the reasonable 70-foot rise from the sea. The canal could take coastal craft of less than 100 tons and, as well as goods, a passenger trade began to grow too.

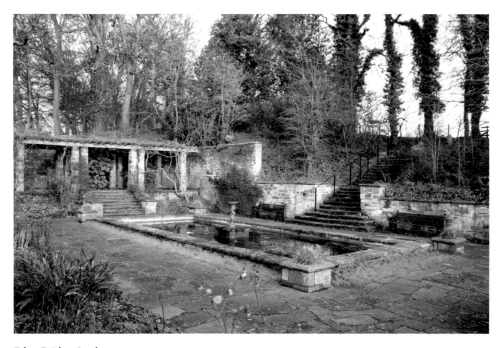

Eden Bridge Gardens.

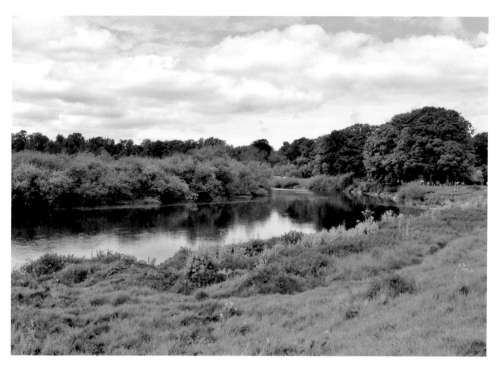

Rickerby Park and the River Eden.

The war memorial.

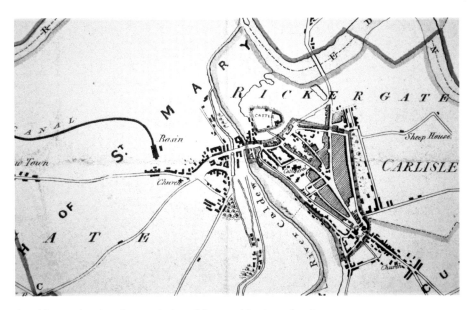

An old map showing the proximity of the canal basin to the city.

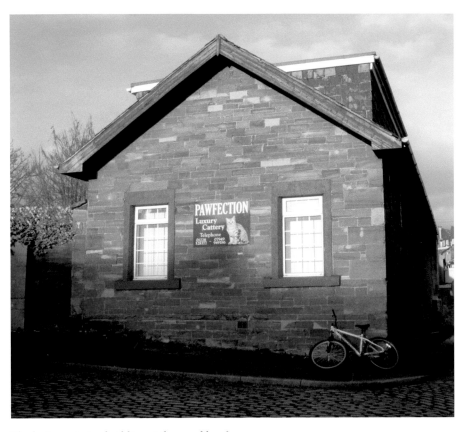

The last remaining building at the canal head.

Canal Street.

The rise of the railways from the mid-1800s began to take over passengers and haulage, and in 1853, just thirty years after opening, the Carlisle Canal was closed. In 1854 a railway opened using the canal bed as its route from Carlisle to Port Carlisle, but as the port declined so did the need for a rail link, and in 1932 the railway branch line to Port Carlisle was closed. Freight services had been withdrawn in 1899, but a horse-drawn passenger service using Dandy cars instituted in 1863 continued until 1914, when it was replaced by steam. There were four horse-drawn Dandy cars built by the North British Railway for use on the Port Carlisle to Carlisle Railway.

There is still evidence of Port Carlisle. In Carlisle, the last building at Canal Head is now a domestic dwelling and the street names are clues as to the canal's former existence.

Carlisle Station

The Carlisle Citadel railway station opened on 10 September 1847 for the Lancaster & Carlisle Railway. It also served the Caledonian Railway, the Maryport & Carlisle Railway and the Newcastle & Carlisle Railway. Once the Midland Railway reached Carlisle with the Settle–Carlisle line in 1876, it was rebuilt and enlarged in 1878–80. Due to the complexity of being served by seven different railway companies, in 1861, by Act of Parliament, they established the Citadel Station Joint Committee to manage the station.

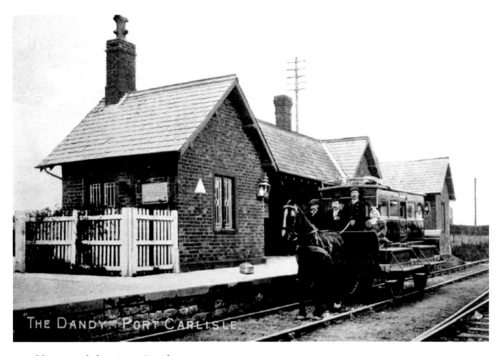

An old postcard showing a Dandy car.

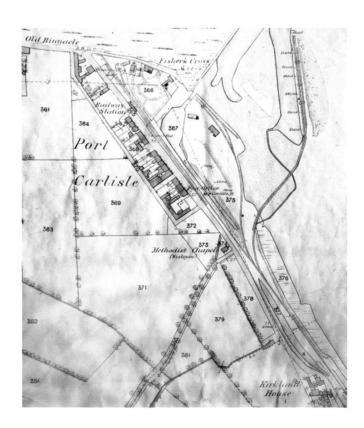

Port Carlisle Canal.

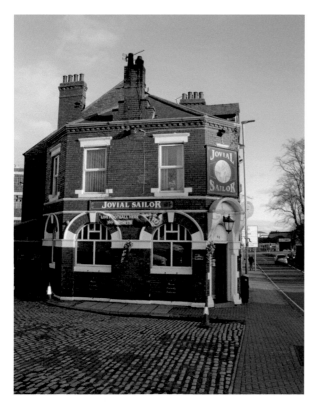

The Jovial Sailor, near the canal basin.

Canal mouth at Port Carlisle.

The architect who designed the London Stock Exchange, Sir William Tite, built the station in a Tudor style and included decorated Gothic fireplaces, a charming clock tower and linen-fold wood-panelled doors. It had a 7-acre (2.83-hectare) glass roof with giant Gothic wood screens at each end, but after they had been painted over in black as an air-raid precaution in the Second World War they suffered from neglect and were demolished in 1957. The building is among the most important early major railway stations in Britain.

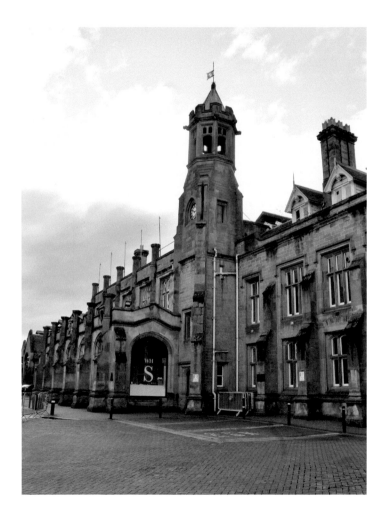

Carlisle station.

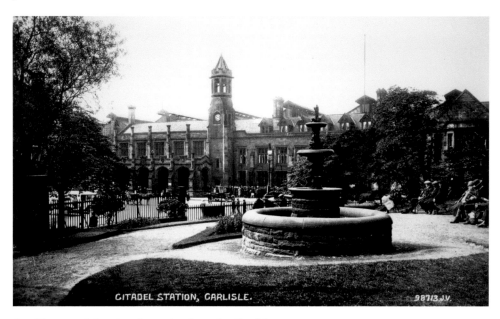

An old postcard showing the station from the Citadel.

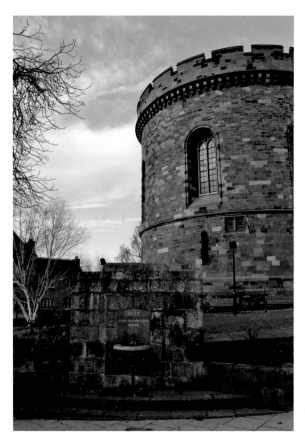

Water fountain memorial to Mayor Robert Ferguson.

4. Secret Weapons, Air Crashes and Cold War Installations

Canal Defence Light

Between Carlisle and Penrith there are many stately homes. During the Second World War their vast remote parklands served as a useful base to train armoured divisions in the use of secret weapons. As early as 1941, Winston Churchill commandeered Brougham Hall and Lowther Park for the development of a top-secret weapon. The Canal Defence Light (CDL) was a weapon based upon the use of a powerful searchlight mounted on a tank, intended to be used during night-time attacks. The light would highlight enemy positions, making them easier to target, but with a secondary use to dazzle and disorient enemy troops, making it harder for them to return accurate fire. The name Canal Defence Light was part of the deception regarding the device's true purpose.

A Matilda tank had a modified turret that mounted a powerful carbon-arc searchlight, which was estimated to be the equivalent of 13 million candlepower. It was expected that

CDL tank with an unusual turret.

later another variant or an American-supplied tank would take over the role as, though the Matilda was well armoured, it was slow and had an underpowered main gun. The Matilda was originally designed as an infantry support tank and not as an offensive fast-moving weapon, demonstrated so effectively by the Germans during the battle for France in 1940. The only surviving CDL-equipped Matilda tank is in the impressive collection at the Tank Museum in Bovington, Dorset.

A rumour circulating the area at the time was that the army was said to be developing a science-fiction death ray. The bright beams of light were seen in the Cumbrian night sky by the locals and imagination filled in the gaps of knowledge. The army learnt to operate their specialised vehicles by driving through the countryside and advancing on selected targets with their lights beaming away, fuelling the rumours already thriving among locals.

Following these trials it was soon understood that the CDL searchlight beam only blinded the defenders directly in front, rather than providing defence in depth. The lights silhouetted the attackers to any enemy on the flanks or would highlight your location to the enemy. The system could only be used in the case of frontal assault or if the circumstances were very favourable to the attacker. The CDL was never used for its intended purpose and only saw use by US forces in protecting bridges after the crossing of the Rhine in March 1945. The Germans tried to attack the bridges at night using swimmers and floating mines, but with the armoured CDLs in position their task was much more difficult. The CDLs were more suited to this task than conventional searchlights because in some areas the east bank was held by German forces who subjected the CDL tanks to artillery and small arms fire.

Eden Valley.

Eden Valley.

Other estates in the area, like Greystoke near Penrith, were used as training grounds. Further east along the A66 is the Warcop Training Centre, established in 1942 as a tank gunnery range. Almost all the armoured formations that took part in the D-Day landings trained in the challenging terrain of the area.

Carlisle Royal Observer Corps Post and Carlisle ROC Group HQ

During the 1950s and 1960s a network of Royal Observer Corps nuclear-monitoring posts was secretly built throughout the country. Many of these underground bunkers were closed during the 1990s and still exist but under private ownership. The area around Carlisle was no exception.

One of the posts was located on the east side of the A689 Kingsway Road within the Carlisle RAF Maintenance Unit. The post was opened in 1961 but closed in 1991 and has since been demolished to make way for new development, with new roads and industrial units known as the Kingstown Industrial Estate.

Another was based at RAF Carlisle, designated the Royal Observer Corps No. 22 Group Headquarters in the UKWMO Western Sector. This was demolished in 1996 and only the concrete base remains, though the compound is still visible and now houses a mobile phone mast and other buildings. This site still retains some of the old buildings and part is now used as the HQ for 1862 Sqn Air Training Corps.

RAF Dakota Crashes in Carlisle

On 31 December 1945, an RAF Douglas C-47A Skytrain (DC-3) was landing at Carlisle but overran the landing strip and hit several wooded barracks. All three crew members escaped without any injuries, but the aircraft was destroyed when a fire caught hold.

Avro 504. (Photo courtesy of Jim Rutland)

Avro 504 Air Crash, near Carlisle

On 1 December 1921, an Avro 504 caught fire in flight near Kirkandrews-upon-Eden and attempted an emergency landing in an open field nearby. The pilot was uninjured, but the aircraft was completely destroyed by fire.

5. Bridges

Carlisle's bridges have always been important to the city as throughfares, crossings, vital communication roadways and as defensive structures.

Harraby Bridge

Harraby Bridge is the main entrance to the city from the south and has been around since at least the medieval times. Records from 1363 and 1380 ask for money for the upkeep of 'the bridge over the Petteril between Carlisle and Harraby' or 'the bridges at Harraby and Botcherby'. In the 1420s floods destroyed the bridges around Carlisle, causing Richard Neville to petition the king for oaks from Inglewood Forest to make repairs. Repairs were required again twenty years later, but this time it was 'the mayor and citizens petitioned the King for a further supply of oaks'.

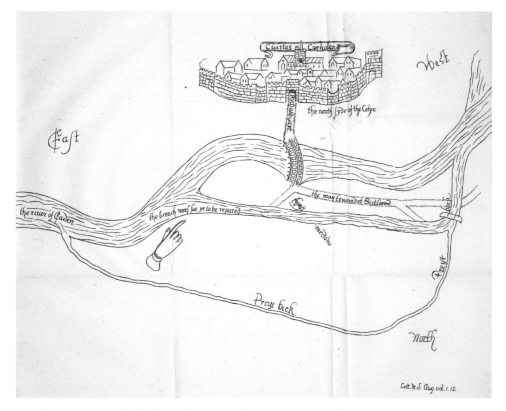

An old map showing the bridge with many arches over the River Eden.

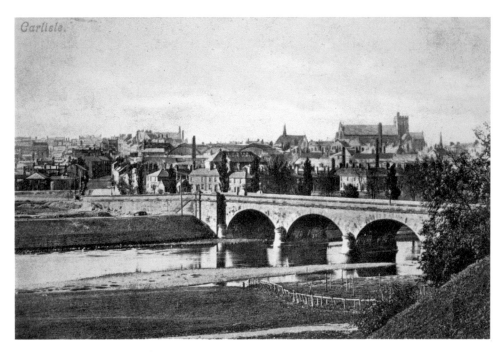

An old postcard of Eden Bridge.

In the 1550s watchmen were placed on the bridge to protect the approaches to Carlisle. In 1608 it is referred to as Gallows Bridge due to its proximity to the place of execution on Harraby Hill. Repairs are mentioned again in 1735, and in 1828 the County Sessions mention the bridge is in a 'very dilapidated state' and it was feared that it may not last another winter. A new bridge was recommended and although initially the demolition and initial build commenced apace, the weather slowed completion. The bridge was finished in 1830.

From 1939 to 1941 the bridge was being widened and extra arches were added; there is a plaque on the parapet to show the work completed in February 1941.

Eden Bridge

Maps from the 1790s to 1811 show two branches of the River Eden being bridged from Rickergate to the Sands and from the northern part of the Sands to Stanwix. Older maps show a crossing from 'Rychardgayt' towards Scotland with a series of arches and further smaller crossings across becks over to the border. There are records of the two wooden bridges over two branches of the River Eden, with the north branch known as Priest Beck. In 1356, Gilbert Welton, the Bishop of Carlisle, issued an indulgence (partial remission of the punishment of sin) of forty days to any who would contribute towards repairs of these bridges. In 1600, when one of the bridges had fallen down and the other was in a poor state of repair, an Act of Parliament was passed for rebuilding the two bridges in stone, paid for by the local authority. The north bridge was called Priest Beck Bridge and the south bridge was Eden Bridge.

Eden Bridge.

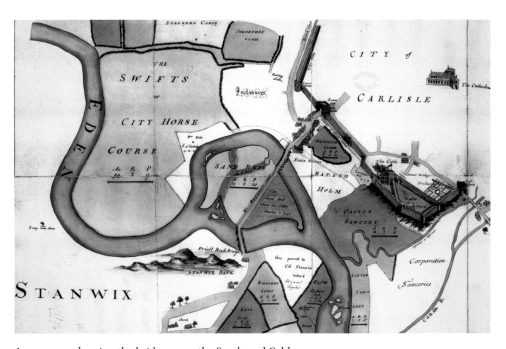

A 1752 map showing the bridges over the Sands and Caldew.

In 1807, 200 years later, an Act was passed to rebuild the bridges. A single bridge designed by Robert Smirke, known as New Bridge or Eden Bridge, was to be built over the northern branch of the river. The southern bridge at this time was to become no more than a causeway. The project was finished in 1815. Later, in 1932, the bridge was widened to accommodate motor vehicles. A plaque records the event.

Caldew Bridge/Nelson Bridge

Another bridge to the west of the city and crossing the River Caldew is show on maps as early as 1576. Shown to the west of the castle from the Irish Gate, also known as Caldewgate, a map from 1774 shows three arches with cutwaters. The current bridge was built in 1853 by various subscribers from local industry.

DID YOU KNOW?
In 1847 Carlisle had around 138 pubs. With a population at the time of *c.* 55,000, that equates to a pub for every 399 people, a percentage of which would be children.

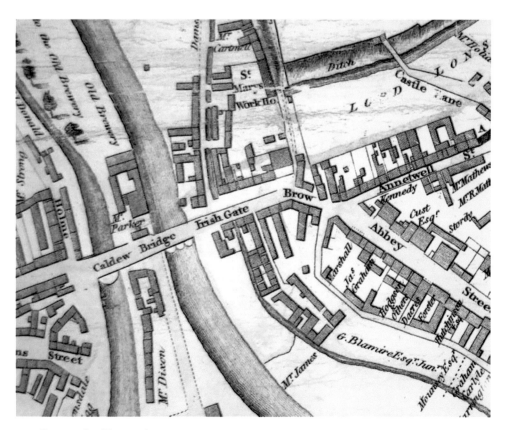

Wood's map of Caldew Bridge.

Close to the bridge stood the Nelson Bridge Inn (also known as the Nelson Bridge Hotel), built sometime around 1856. It closed in 1971 before being demolished in 2005 when the bridge was widened.

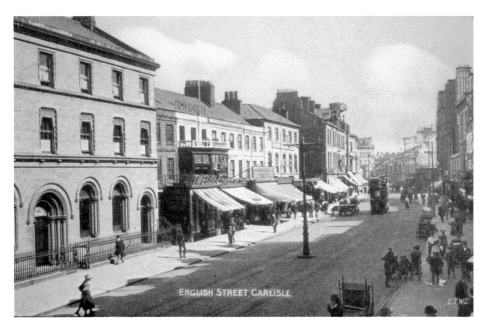

An old postcard of English Street.

An old postcard of Botchergate.

6. Victorian Opium Use

In 1819, a letter was sent from the Earl of Carlisle to Revd William Vernon regarding a bill for establishing regulations for the sale of poisonous drugs. The bill proposed to require sellers to label poisonous medicaments, preventing 'dangerous and fatal accidents [that] frequently occur, from certain Poisonous Drugs and Medicines being mistaken and sold for those of a useful and harmless quality'. Yet it was not until much later that serious restrictions were in place to restrict and regulate the sale of poisons under the Pharmacy and Poison Laws of 1892.

It is known from early writings that the ancient Egyptians had an interesting way of dealing with the noise of crying babies: they would administer a draft of opium. The practice was still very much in use during Victorian-era Britain, until it was realised the dangers the use of children's opiates posed to general health.

Opium was known as 'The Poor Child's Nurse' from an 1849 issue of British humour magazine *Punch*. We know that in this era opium was readily used as a cure for a bad cough or general aches and pains, but it is less well known that opium was also given to children and even babies – especially noisy babies. Restless or teething babies and small infants would be given concoctions such as Mrs Winslow's Soothing Syrup, which contained morphine (an opium derivative). There were at least ten brands of mixtures aimed at children and infants, including Atkinson's Royal Infants' Preservative and Street's Infants Quietness. The most famous preparation of children's opiates was Godfrey's Cordial, which was a mixture of opium, treacle, water and spices.

Medical officers during this period were convinced that opium was a major cause of infantile death. Its use had become widespread among working-class families. One Manchester druggist even admitted to selling between 5 and 6 gallons of 'quietness' every week. The scale of infant mortality at the time was not fully known, as coroners often recorded the cause as 'starvation'. Lozenges or pastilles containing opium were often displayed within pharmacy shop cabinets in rows – very much like a sweet shop.

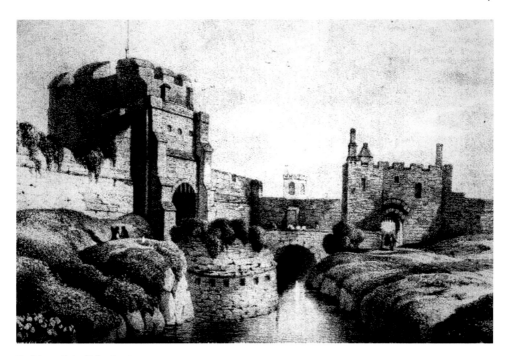

Etching of Carlisle Castle.

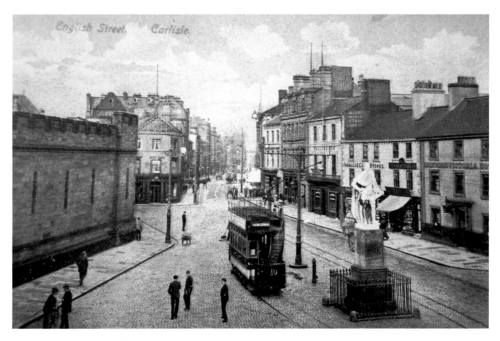

An old postcard of English Street.

Fisher Street.

Annetwell Street and Abbey Street.

West Tower Street.

West Walls.

West Walls by the Cathedral Precinct.

Bridge over St Cuthbert's Lane.

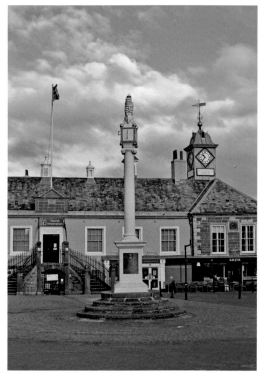

Market Cross.

Part of the wall with tower.

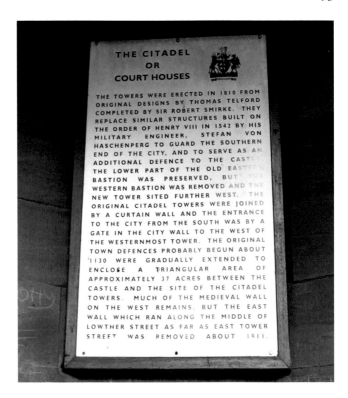

Citadel plaque.

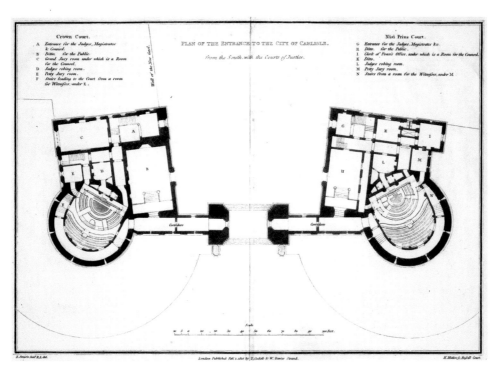

Citadel plan.

Sportsman public house.